# RHODE ISLAND BASEBALL

# RHODE ISLAND BASEBALL

## The Early Years

Rick Harris

Published by The History Press
Charleston, SC 29403
www.historypress.net

Copyright © 2008 by Rick Harris
All rights reserved

*Cover image*: The Rhode Islands, 1876. *Rhode Island Historic Society.*
Cover design by Marshall Hudson

First published 2008

Manufactured in the United Kingdom

ISBN 978.1.59629.496.7

Library of Congress Cataloging-in-Publication Data
Harris, Rick.
Rhode Island baseball : the early years / Rick Harris.
p. cm.
Includes bibliographical references.
ISBN 978-1-59629-496-7
1. Baseball--Rhode Island--History. 2. Baseball players--Rhode Island--Biography. 3. Baseball teams--Rhode Island--History. I. Title.
GV863.R47H377 2008
796.35709745--dc22
2008022579

Notice: The information in this book is true and complete to the best of our knowledge. It is offered without guarantee on the part of the author or The History Press. The author and The History Press disclaim all liability in connection with the use of this book.

All rights reserved. No part of this book may be reproduced or transmitted in any form whatsoever without prior written permission from the publisher except in the case of brief quotations embodied in critical articles and reviews.

In Memory of My Mother

Katie "Home Run" Hudson (Priolo)
(1929–1999)

A barehanded third baseperson, she handled the hot corner for her Maxwell, Iowa softball team and was known to loft a good many balls over the left field fence. She was also one of the most encouraging and kindest people I have ever known.

# Contents

Preface .................................................................. 9
Acknowledgements ........................................... 13
A Brief History of Baseball in Rhode Island ....... 15

**PART I: The National Pastime and the Origins and Development of Baseball in Rhode Island**
Chapter 1    Before Baseball .................................................. 21
Chapter 2    Notes on the Development of the National Pastime ........ 27
Chapter 3    Women, Rhode Island and Baseball .................. 39
Chapter 4    The Soldiers' Pastime ........................................ 55
Chapter 5    Who Killed the Dead Ball? ................................ 63
Chapter 6    Historical Notes ................................................ 69

**PART II: The Players**
Chapter 7    Joseph Start ...................................................... 81
Chapter 8    Hugh Duffy ....................................................... 85
Chapter 9    Charles Leo Hartnett ........................................ 91
Chapter 10   Napoleon "Larry" "Nap" Lajoie ...................... 99
Chapter 11   Frederick Eugene "Gene" Steere .................... 111
Chapter 12   Frank Corridon ............................................... 115

**PART III: The Teams**
Chapter 13   Island Park and the Comets ............................ 121
Chapter 14   The 1892 New England League Pennant Winners ...... 127
Chapter 15   The 1914 Providence Grays ............................ 135
Chapter 16   The 1926 Sayles Baseball Club ....................... 143

Bibliography ...................................................... 149
About the Author .............................................. 157

# Preface

This book is a "sampler" of information and stories drawn from Rhode Island's rich baseball past. Buried within the recesses of the Ocean State's collective memory and musty assortment of old, yellowing books and newspapers reside thousands of fantastic and captivating baseball stories—stories of specific people, places and events. This book represents over fifteen years of research and writing dedicated to Rhode Island's fascination with the "Grand Old Game." It is an exploration that has taken me to every one of Rhode Island's more than 450 communities, from places like Saxonville, White Rock, Esmond, Berkley and Valley Falls to the more well-known communities of Woonsocket, Providence, Cranston, Westerly, Newport, Bristol, Pawtucket and more. Still, this book represents but a fraction of Rhode Island's baseball history. After all, Rhode Island's residents have played baseball for a long, long time. Beginning with Williams Latham's diary entries in 1827, this book meanders through "Little Rhody's" baseball heritage, taking the time to make many leisurely stops along the way.

I have tried to provide a snapshot of Rhode Island's baseball past. The real importance of these stories is not baseball itself, but the embedding of a very significant human activity called baseball into our communities. Whether one likes baseball or has paid little attention to the game, it is an integral part of Americans' psychological and communal past. I have come across and written about hundreds more baseball stories than could be included in the pages that follow. This is not surprising since these are stories of everyday life—stories of humor, adventure and hope lost. Baseball does not mimic life, it *is* life.

The images for the color insert have been selected from over a thousand photos because of their ability to historically represent their time period—some because of their connection to Rhode Island, and others because

# Preface

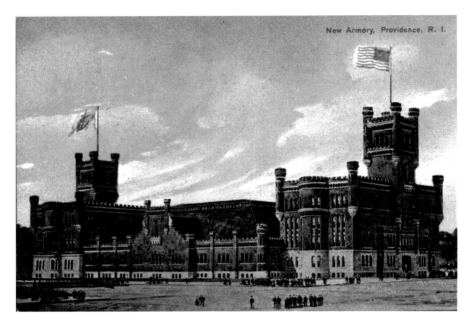

The Dexter Street training grounds, 1910. *Author's collection.*

of their evocative ability to tell their own story. Images convey a vast amount of information through the triadic experience of reasoning, art and imagination. Besides representing the ability of the photographer or artist, images resonate with particular sensitivities and experiences. A family portrait at a picnic may trigger strong emotions related to a family picnic in your own past. A ballplayer standing in front of a house in a Midwestern town may remind you of your own Uncle Bob. From these past experiences, a much more personal connection is created. These images, many of which are "orphan" images saved from auctions and retail outlets, reflect the influence of baseball on American culture throughout the nineteenth and early twentieth centuries. From the warmth and love displayed in pictures of friends and family and the camaraderie expressed in manufacturing and semiprofessional teams to the almost haunting portrayal of individual players, these images contribute essential factual and imaginative details to the historical record of our national pastime—the Grand Old Game of Baseball. Narration has purposely been kept to a minimum.

I invite you to ease into your favorite chair, sit back, relax and take a stroll through the annals of baseball like you never have before. Focus your attention on the dreams and apparitions reflected in each photo. Open

# Preface

your mind and your heart and immerse yourself in each story and you will sneak a glimpse into the archives straight from the collective memories of generations past.

# Acknowledgements

I would like to acknowledge the whole body of authors, whether they be news reporters from the distant past or modern-day baseball researchers putting into print materials I have so respectfully utilized. I would also like to acknowledge the many, many people I have interviewed over the last few years and would like to apologize to those players and/or family members whose stories I have not included in this book. They are all worthy, but space just does not allow the inclusion of all. I will continue to document these accounts of events, adventures and, more importantly, the impact that baseball has had on our lives.

Lastly, I would like to thank The History Press for the great opportunity to publish this book. In the old Zen tradition, one might ask: "Is a story a story if no one reads or hears it?"

# A Brief History of Baseball in Rhode Island

Rhode Island has a rich and wonderful baseball legacy that has been alive and well since the very beginning. The earliest known written document relating to baseball in the United States was an account of a baseball game printed in a New York newspaper in 1823. In 1827, Williams Latham, a Brown University student, described in two of his entries a game of "base ball" that he played on the Brown University commons, making Rhode Island a very early contributor to written documentation of the game. By the 1850s, there is evidence that baseball had firmly taken root in several Rhode Island communities, and by 1860 there was a network of teams that hosted a yearly tournament to determine a "Champion of Baseball" in Providence.

During the 1860s and 1870s, baseball spread through all communities in the Ocean State. The first professional team was the Rhode Islands in 1875, and by 1878 the state had a National League franchise, the Providence Grays (1878–85). Between 1880 and 1890, the State League, a semiprofessional/outlaw minor league, ruled the roost, surpassing the National League Grays in popularity. In the 1890s, minor league teams such as the Woonsockets, Pawtucket Maroons and Newport Colts came of age, while on the community level teams such as the Lightfoots, Narragansetts, Eurekas and many more like them became the heart and soul of small towns and cities alike. During this time, African Americans developed local teams, and women began playing on teams throughout the state.

From the late 1890s to the mid-1950s, mill leagues provided entertainment for hardworking citizens and immigrants undaunted by economic depression, hurricanes and war. In addition to mill leagues, there were church, office, banker, lawyer and physician leagues. Just about everyone played or cheered for local baseball. To date, I have found over 1,370 teams of significance from 1827 to 1960. Baseball became a significant part of the living routine

# Rhode Island Baseball

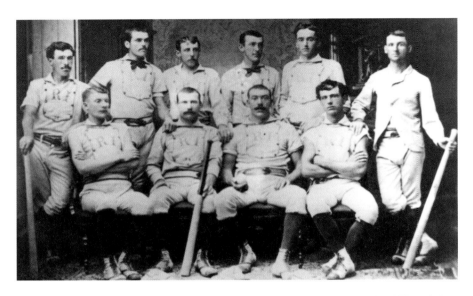

The Rhode Islands, circa 1876, the Ocean State's first professional baseball team. *Rhode Island Historic Society*.

of every man, woman and child in Rhode Island, a fact that did not go unnoticed by entrepreneurial Rhode Islanders.

Rhode Island has hosted fifteen professional teams playing in nineteen leagues. Pawtucket has the bragging rights, with forty-eight years (1893–1936) of professional ball played within city confines, followed by Providence, Woonsocket, Newport, Cranston and West Warwick. In addition to baseball, both amateur and professional, being a noteworthy part of the Ocean State's history, Rhode Island has contributed a number of "firsts" to the national pastime, a few of which are listed below.

## Interesting Rhode Island Baseball Firsts and Other Facts

- The National League Providence Grays won the first World Series, beating the New York Metropolitans of the American Association three games to none in 1884. Providence pitcher, Old Hoss Radbourn, won fifty-nine games in the regular season and all three World Series games.

- The term "bullpen" was created by the Providence Grays. The bullpen was originally created to park carriages of well-to-do patrons.

# A Brief History of Baseball in Rhode Island

- Paul Hines of the Providence Grays was the first player to wear sunglasses during a game, and he completed the first ever unassisted triple play in a major league game.

- The Providence Grays was the first team ever to use a turnstile to count fans entering the ballpark, as well as the first team to wear gray uniforms.

- On April 30, 1879, Providence Grays pitcher and future Hall of Famer John Ward saved his own shutout by backing up home plate on a throw from the outfield. This was the first recorded instance of this play.

- Providence Grays player George Wright was the first victim of baseball's reserve system when he turned down Providence's final offer and could not sign with Worcester.

- On June 2, 1879, Brown University baseball star John Lee Richmond made his professional debut with the Worcester Ruby Legs by no-hitting Chicago in a seven-inning game, eleven to zero. This was a major league's first no-hitter. (Richmond returned to Brown and beat Yale, three to two, for the College Baseball Championship on June 9, 1879.)

- Woonsocket-born Gabby Hartnett holds the world record for catching a baseball from the greatest height, eight hundred feet. He did it twice. The balls were thrown from a blimp in Los Angeles on April 1, 1930.

- Rhode Island hosted the only professional team (Woonsocket Trotters/Prodigals, 1908) ever to end a season with a losing record (zero to one) without ever playing a game.

- Cranston native Hugh Duffy still holds the Major League's highest batting average at .440, set in 1894.

- Warren native Lizzie Murphy was the first woman to have played in a Major League exhibition game, on August 14, 1922.

- In 1973, nine-year-old Allison "Pookie" Fortin from Pawtucket wanted to play Little League and was denied because she was a girl. In 1974, Allison won in court the right to play, not just for herself, but for all girls in the United States.

# PART I

# THE NATIONAL PASTIME AND THE ORIGINS AND DEVELOPMENT OF BASEBALL IN RHODE ISLAND

When we tug on a single thing in nature,
we find it attached to everything else.
—John Muir

And so it is with baseball.

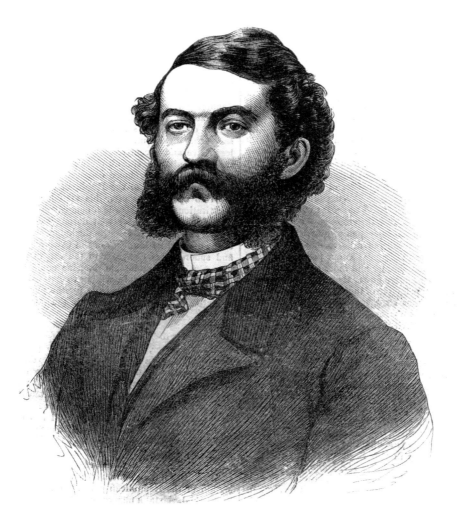

By 1868, baseball had a president, ten thousand young men were playing the game and it was the national pastime. But how did baseball reach these heights, and where did it come from? Harper's Weekly, *Saturday, May 16, 1868. Author's collection.*

## Chapter 1

# Before Baseball

### *Theories on the Origin of Baseball*

### Abner Doubleday, Alexander Cartwright or Product of Cultural Evolution?

Did Abner Doubleday invent the game of baseball as proposed by Albert Spaulding? Did the famed Alexander J. Cartwright, who penned the rules for the Knickerbocker Club, create baseball? Or did baseball grow slowly from the hearts and minds of early Americans? Let us take a quick tour of the possibilities.

### *The Doubleday Theory*

A long, long time ago, on a sunny summer afternoon in the pleasant village of Cooperstown, New York, a crowd gathered to watch as Abner Doubleday displayed an interesting new type of game. Earlier, Doubleday had carefully laid out a set of bases that formed a perfect square (diamond). As the crowd watched, Doubleday instructed his ensemble of gentlemen and provided instruction in the rudiments of the new game. As the game progressed, the crowd and players were so impressed with the improvements to the old game of rounders that they were immediately sold. So enthralled with their experience in that sun-drenched field, they quickly helped to spread the game across the Northeast and into the South. The game invented by Doubleday was to become known as baseball—a truly American invention—and by the late 1850s all America would know it by its assigned designation: the national pastime.

    While it is certainly a nice story, it is a little flawed. Abner Doubleday did not invent baseball on that afternoon in 1839 while visiting the village of Cooperstown in upstate New York. In fact, he never claimed to be connected with the game, and there is no evidence to suggest that Mr. Doubleday visited

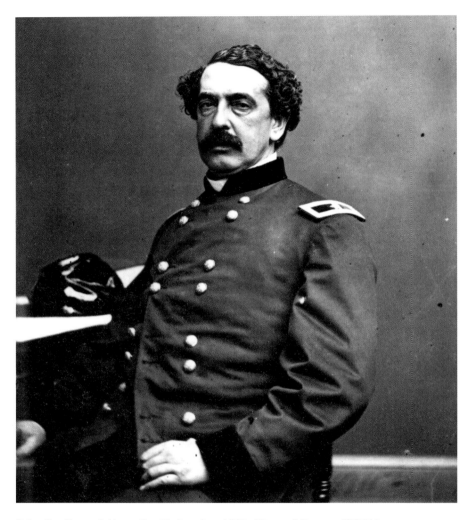

Brigadier General Abner Doubleday, circa 1865. *Library of Congress, ZZ6510.*

Cooperstown that year. The myth appears to have been a fabrication of one Abner Graves, who had been a classmate of Doubleday's in Cooperstown. Graves relayed the story to Albert Spaulding, who in turn promoted the idea to feed the patriotic fervor of the time. To accept that the game could have developed from the foreign games of cricket and rounders would have been contrary to the theory that the game was purely American and would have appeared anti-American. As for Doubleday, he would go on to become a great and important figure in U.S. history as a general in the Civil War, not as the inventor of baseball.

# Before Baseball

## *Alexander Cartwright*

On September 13, 1845, a group of gentlemen formed the Knickerbocker Club. The club's purpose was to provide a gentlemanly sporting opportunity by way of an outdoor contest of mind and body. Many versions of stick-and-ball games were played at the time. Towns and neighborhoods across the New England states sported formalized clubs that played one another accordingly. The Knickerbocker Club elected Alexander Cartwright to chair the rules committee, and within ten days he presented his slate of rules, which were accepted by the club. This slate of rules codified how the game was to be played and set the stage for a standardization process that would take over a half century to complete. These rules laid the foundation of the game we know today as baseball. No one truly knows whether the rules were completely made up or simply drawn from the existing practice of several games. Alexander J. Cartwright did compose the basic rules in 1845, but did he invent the game? If not, where did baseball come from? As was suggested previously, it may be a matter of semantics.

## *Like a Good Folk Song*

Like a good folk song, the origins of baseball cannot be traced to a single event or even a particular span of time. Culture, which includes baseball, evolves from the masses over a long period of time, with influences coming from other cultures and many individual contributions. Even when the term "baseball" came into existence is very much debated. In the book *Total Baseball*, historian David Q. Voigt writes that in the early 1820s, the grandfather of the late novelist Samuel Hopkins Adams recalled playing "base ball" in Mr. Mumford's pasture, a declaration that would have placed the term's use around 1760. Voigt's research also found that, in 1834, Robin Carver's *The Book of Sports* stated that an American game called "base" or "goal" ball was rivaling cricket in popularity, and in 1777 soldiers of the Continental army at Valley Forge played a game where a ball was batted and the batter then rounded a set of bases. In 1771, a town ordinance was passed in Pittsfield, Massachusetts, prohibiting the "game of ball" on the commons next to the town meeting hall. (The ban was a result of one too many broken windows.) Early settlers reported that the native population played a game in which a rounded stick was used to bat a ball of deer hide. In 1825, the following account appeared in the *Delhi Gazette* (New York):

# Rhode Island Baseball

### A Challenge

*The undersigned, all residents of the new town of Hamden, with the exception of Asa C. Holland, who has recently removed into Delhi, challenge an equal number of persons in any town in the County of Delaware, to meet them at any time at the house of Edward B. Chance, in said town, to play the game of BASE-BALL, for the required sum of one dollar per game. If no town can be found that will produce the required number, they will have no objection to play against any selection that can be made from the several towns in the county. Eli Bagley, Edward B. Chance, Harry P. Chance, Ira Peak, Walter C. Peak, H.B. Goodrich, R.F. Thurber, Asa C. Howland, & M.L. Bostwick*

The wording of the challenge strongly indicates that by 1825, a definite set of rules applied to the game of "Base-Ball" and that wagering was very much part of the game, even then. As will become clear, money was a prime motivator for the expansion of the game, and extensive unscrupulous activity by players and community participants was not uncommon. Although baseball developed over a long period of time, with many influences, there are certain types of games and events that have made particular contributions to its evolution.

## *Cricket*

Cricket is an old English sport that was developed sometime in the fourteenth century. The game requires the use of a flat bat, a ball and two "wickets" or bases. Cricket contributed several key words to baseball vocabulary, including umpire, out, striker (strike) and fielder, as well as the concept of bases. Press coverage for town cricket games rivaled baseball coverage right up to the early 1900s. Many of the early professional ballplayers were also cricket players.

## *Rounders and Town Ball*

The origins of the game of rounders (town ball) are not known, although its roots may have been English. Little information regarding the development of this game, which was definitely a precursor to baseball, has been found. One might assume that the name "rounders" referred to the fact that a batter needed to "round" the bases to score, as opposed to going back and forth as in cricket. But this is only speculation. In the 1864 edition of *The American Boy's Book of Sports and Games*, the game of rounders was described in great detail and with high expectations, as the first sentence indicates:

# Before Baseball

Cricket players, uniforms and equipment. Harper's Weekly, *circa 1865. Author's collection.*

Nestled among the want ads is an announcement relating to the first Convention of Baseball Clubs, which was organized by the Knickerbockers Baseball Club. The convention led to the establishment of the National Association of Base Ball Players. Porter's Spirit of the Times, *January 17, 1857. Author's collection.*

> *This game, which Rounders, or Town Ball, reduced to a system, and governed by scientific rules, is a graceful and invigorating pastime, and bids to become to this country what cricket is to England—the national game.*

However, this book was a little behind the times. By 1864, the basic rules of baseball had been established. Town ball and most other ball-and-stick games gradually lost out to baseball's popularity. The only other rival baseball-like game played at the time was a brand of ball called the "Massachusetts Game," which used four-foot-high stakes as bases. Imagine taking a headfirst slide into a third base that was a stationary four-foot pole! Evidently, the contemporaries of the time figured out that a flat base was somewhat more practical, and by the end of the decade Cartwright's "New York Game" had won out.

Throughout the 1850s, baseball developed and grew to great popularity. By 1858, the stronghold that the New York–based Knickerbockers and their gentlemanly rivals had on the game was upended by the newly formed National Association of Base Ball Players, a twenty-five-member group of amateur teams from all over the country. When the Civil War broke out, the game that Cartwright had spawned was popular all over America and was played extensively by Union and Confederate soldiers. By the end of the war, baseball had eliminated all rivals and become the national pastime.

## Chapter 2

# NOTES ON THE DEVELOPMENT OF THE NATIONAL PASTIME

*Important Influences, Events and Sociological Aspects*

### POPULARITY AND THE ROLE OF COMMERCIALISM

There are many factors that helped spawn the growth of baseball in the early years. The fact that the game was a "team sport" and had a set of standardized rules helped immensely. Westward movement of the population and the coming together of soldiers from all walks of life during the Civil War also contributed significantly. Baseball has grown to almost mythical status because Americans like a good story—and baseball has countless good stories. There have been many well-thought-out explanations written about why baseball has become so popular over the years, and all are probably true. One factor, however, that is not often touted is commercialism. From the beginning, entrepreneurs of all persuasions saw the growing popularity of baseball as fertile ground from which to make a buck.

One of the earliest of the entrepreneurial-minded companies was the Beadle's Publishing Company. In 1861, Beadle's began publishing its *Beadle's Dime Base-Ball Player* book. This book provided player/team statistics, the rules of baseball, advice on playing positions and, most importantly, a diagram of the dimensions of the field. During the earliest years of baseball, there were few permanent fields. Most of the time, players simply marked off the field in a convenient, available and relatively flat space. Accurate and visual guidelines were important for the purpose of creating standardization of games, and as a byproduct, they prevented a lot of arguments. *Beadle's Dime Base-Ball Player* provided the necessary venue.

Albert Spaulding and Al Reach capitalized on their successful playing careers and established multimillion-dollar sporting goods businesses. Equipment manufacturers and retailers, including Spaulding and Reach, sparked the imagination and desire of young men and women across the

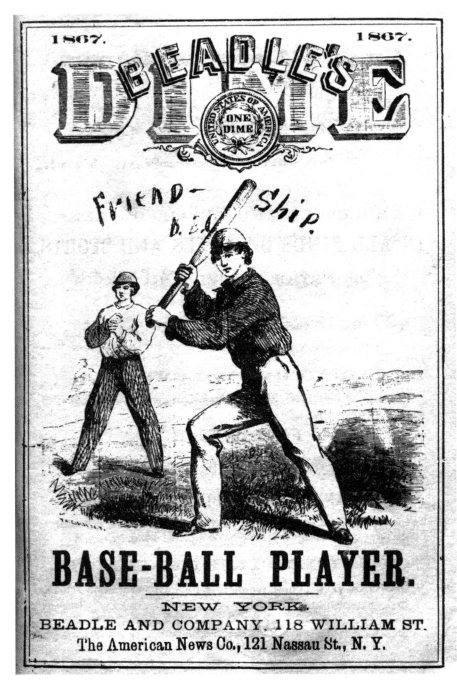

*Beadle's Dime Base-Ball Player.* Beadle Publishing Company, 1867. *Reproduction. Author's collection.*

# Notes on the Development of the National Pastime

country. It is not hard to imagine boys and girls spending many an hour reading about the mechanics of the game and reviewing statistics of baseball's star players, as published yearly in the Spaulding and Reach baseball guides. Both Spaulding and Reach set equipment standards for sandlot and professional play. Perhaps more importantly, their catalogs were the catalyst that changed dreams to reality. The guides were also a convenient and efficient way to sell sporting goods.

Other forms of commercialism also brought the game to the national forefront in popularity. Legal and sometimes illegal (gambling and game fixing) profit could be made from the spread of the game. Prior to the formation of the Cincinnati Red Stockings, the first all-professional team, the game was considered to be a "gentleman's" endeavor, at least on the surface. In reality, by the mid-1860s, gambling had a firm hold on the game of baseball.

Gambling as a pastime, in general, far outdistanced in popularity more respectable forms of sport. Baseball could not escape this fact. Just twelve short years after Cartwright developed the rules regarding the gentlemanly game of baseball, New York City's mayor, Boss Tweed, managed to totally corrupt the game. There were many spectators who were very willing to accommodate this corruption. Tweed's team, which was originally formed by the New York City Hook and Ladder Company No. 1, became the earliest and perhaps the most well-known "dirty team," surpassed only by the Black Sox of 1920. Tweed "employed" his ballplayers as attendants in the city morgue, where they were never required to actually work. In addition, many of his players were not averse to taking a sawbuck under the table to influence the outcome of a game or two. The practice of influencing ballgames for illegal profit would continue right up to the Black Sox scandal. The practice of making a buck by throwing a game was so prevalent that even a few well-known players participated on occasion. The gambling motivation, whether betting on honest or dishonest games, certainly encouraged crowds to attend in numbers.

The gambling motivation was particularly prevalent in Rhode Island during the 1880s. Train loads of baseball "cranks" would attend games played between rival towns, and the money was very loose. There were several instances in which constables were called to protect an umpire from angry crowds that felt he had miscalled a game. The most well-known Rhode Island facility for gambling, drinking and rowdy behavior was the Palace Gardens in Lakewood in the 1920s. Up to eight games could be played at one time at the Palace Garden grounds. The spectators were well served in the liquor department, and any attempts by constables to break up the games were easily thwarted by rowdy fans.

Commercialism of the legal sort was probably the key factor in making the game so popular. From the early 1870s on, baseball was considered a business and owners expected to make a profit. Backers of teams were successful businessmen who were enamored with the idea of owning a sports franchise. For some, the motivation may have been based on a love for the game, but for many owners, ownership itself was simply a rich man's "sport." Lastly, some owners used the game to promote their own products, including sporting goods or brewed beer. All owners took advantage of selling sponsorship and advertising space, and to this day the game of baseball and business are inseparable.

## Spiritualism, Nostalgia and Baseball's Popularity

There are many facets to culture and many more to being human. As a product of human activity, baseball can not escape this fact. If one could pick a single spiritual philosophy that would encompass the nature of baseball, it would have to be Zen. Baseball contains so many paradoxes, is so complex and yet so simple that it almost defies logic. The game is played in many nations, yet it retains its true American form. Each and every game is remarkably consistent with a host of statistics for just about all outcomes, yet each game in itself takes on its own life and personality. The final outcome of the game is a direct result of the players involved, the ambiance of the ball field, the crowd and the weather. Statistically, the all-encompassing and unwritten "book" of baseball allows a manager to make decisions that rely on over 150 years of wisdom, yet the "book" often is proven wrong by the actions of an individual or the influence of the collective spirit of the team. Players call upon their luck, karma, prayer and/or rituals, and it is the belief in these nonscientific principles that is often the harbinger of an unpredicted outcome.

In some respects the game is so incredibly simple. To quote Kirby Pucket, "You see the ball, you hit the ball. They hit the ball, you catch the ball. You catch the ball, you throw the ball. That's it." This statement is absolutely true; however, another famous ballplayer's observation also rings with truth, but indicates that baseball is anything but predictable. In 1973, Yogi Berra said, "It ain't over 'til its over." Zen represents a balance of seemingly opposite facts or states of being. In baseball, scientific method and the art of intuition live hand in hand; statistics and improbability coexist; collective wisdom and eccentricity complement each other. For example, consider Nolan Ryan's straightforward fastball and Mark Fedrich's

# Notes on the Development of the National Pastime

conversations with the ball on the mound. If you are still in doubt, just review the literature from ballplayers' testimonies and scientists' research related to the controversy surrounding the question of whether a "curve ball" really curves. Baseball, the "steadfast tradition," and baseball, the "coup le destin," maintain a precarious balance.

Of course, no American from the mid-1800s would have known anything of Zen concepts encased in baseball, and certainly only a few enlightened folks were that engrossed in the development of American culture. But the philosophical underpinnings of the spirit of America develop whether people realize it or not. Baseball, the truly American game that has survived wars, depressions and constant ideological conflicts, is an exemplary illustration of this process of collective philosophical growth.

## Amateurism Versus Professionalism

The game of baseball was conceived as a "gentlemen's" sport, as a means to exercise the body and discipline the mind. Great measures were taken to enforce the rules of decency and provide an opportunity to exercise the virtues of honor. Whether the game was played between rival gentlemen's clubs or college teams, much was made of the "social" aspects of the game. Throughout the 1850s and '60s, these concepts held true in the ideal sense. However, ideals do not last long in the real world, and the concepts of professionalism slowly encrusted the game. During the 1860s, it became clear that some players had more talent than others. It also became clear that money could motivate these better players to swear allegiance to a particular team and allow good players to devote more time to the honing of baseball skills.

By 1866, many teams had players who were compensated by straight-out cash or given "ghost" jobs to compete on a factory- or city-sponsored team. By the end of the decade, the ground was fertile for the first full-fledged adventure into pure professional baseball. At the end of the 1868 season, the National Association of Base Ball Players, which governed baseball by default, adopted Rule V, Section 7:

> *All players who play base-ball for money, or shall at any time receive compensation for their services as players, shall be considered professional players; and all others shall be regarded as amateur players.*

From the edge of western civilization came the first team to establish itself as an all-professional baseball team—and establish itself it did! On May 4, 1869, the Cincinnati Red Stockings played its first game as a professional team and beat the Great Westerns forty-five to nine. This game would represent the beginning of an eighty-four-game winning streak that would not end until the following summer. On June 14, 1870, the Atlantics of New York defeated the Red Stockings eight to seven. New Yorker Joe Start played a key role in the defeat by knocking in the tying run in the bottom of the eleventh. (See chapter 7 for more on Joe Start.)

Harry Wright managed the Red Stockings, and the team enjoyed great financial backing. The team was extremely successful and helped spread the game across the country. In its famous eighty-four-game run of victories, Wright's brother George hit for a .519 batting average, scored 339 runs, had 59 home runs and would have been a Gold Glove recipient if gloves had been in use. (Until the 1880s, all fielding was performed barehanded.) It is impossible to view 1869 baseball according to today's standards; however, George's stats would have been impressive over a 162-game schedule, equivalent to 512 runs scored and 90 home runs. George and his brother Harry are both in the Baseball Hall of Fame in Cooperstown, and George would later distinguish himself as a premier player with the Boston Beaneaters and Providence Grays. The Cincinnati Red Stockings' first year became known as the Great Tour of 1869.

If professionalism spurred the expansion and growth of baseball, amateur and semiprofessional baseball were to be the fertilizer. By 1890, every town of any size sported amateur and semipro baseball teams. Most colleges also had several teams, and all cities supported not only teams, but many had leagues as well. Baseball in everyday working America was serious business and competition was fierce.

## League Ball

### *Solidification of Professional Baseball*
A major force in creating the stability that baseball now enjoys was the development of the "league concept." It would seem that Americans maintain, at the forefront of their sporting desires, the need to establish "bragging rights," or to put it in modern terms, to establish who is number one. There are two ways to determine which team holds the right to declare itself champion. The first is the method college football uses today: the "poll." This system relies on subjective comparison to establish a ranking

# Notes on the Development of the National Pastime

order. When baseball was first developing, polling was used to decide who was best in any given area. Ascertaining the championship team was not always done through an official poll, but through countless barroom arguments (sometimes brawls) and through the press, which drew on the collective wisdom of the "men who were in the know." The second way to determine a champion was to provide a format for face-to-face competition through a standardized schedule, with guidelines to ensure fair scheduling. This organization requires the formation of leagues. As baseball developed in the late 1860s, the concept of city leagues, and eventually regional/national leagues, also developed.

Now, instead of the amateur National Association of Base Ball Players, which had been established primarily to write rules and procedures, leagues performed these tasks, as well as provided a way of establishing a "winner." The winner of a league eventually became known as the pennant winner (winner of the league flag). Perhaps the most important role of the formation of leagues to baseball, however, was the linking of many individual and regional interests that were fueled as much by the lure of money as by establishing a champion. With more organization and the policing of owner's actions came more stability from a financial standpoint.

In the beginning, leagues that brought together regional and national concerns were professional in nature. The first major league, the National Association of Professional Baseball Players, was born on March 17, 1871. Teams included were:

| | |
|---|---|
| Brooklyn Atlantics | Rockford Forest Citys (Illinois) |
| Philadelphia Athletics | Fort Wayne Kekiongas (Indiana) |
| Boston Red Stockings | New York Mutuals |
| Chicago White Stockings | Washington (D.C.) Nationals |
| Brooklyn Eckford | Washington (D.C.) Olympics |
| Cleveland Forest Citys | Troy Union Club (New York) |

This league did not have strong central leadership. Teams made out their own schedules, a process that led to discrepancies in levels of competition and of games played. Some teams were more interested in their barnstorming schedule, which brought in more money than league games. Although league organization helped some teams make money, the league failed to fulfill the other reason for organizing; that is, to establish an uncontested champion. After five inconsistent years, the league went out of existence and a new professional league was created.

# Rhode Island Baseball

On February 2, 1876, the National League was formed, and despite many challenges, it remains to this day. The stronger central organization of the National League, with its ability to sanction owners and players alike, resulted in consistent schedules and established public confidence in competitive outcomes. As a matter of local interest, the oldest professional baseball franchise in continuous operation is the Atlanta Braves. Of course they weren't in Atlanta when the franchise was born. The Braves began in Boston as the Red Stockings and were a founding member of the National League in 1876. While in Boston, the team was also known as the Red Caps, Beaneaters, Nationals, Doves, Rustlers and, of course, the Boston Braves (Bees). In 1953, the franchise moved to Milwaukee, and then in 1966 it moved to Atlanta.

## The Pyramid of Life or How the Minor Leagues Were Created

Like it or not, much of American culture, despite its diversity, is built on concepts embedded in capitalism. Power, privilege, wealth, political clout, determination and luck are all important ingredients in capitalism. They are the same ingredients that were important in the development of professional baseball. Fortunately, baseball is not life or death; it is only a game…sort of.

Baseball has had its share of behind-the-scenes business maneuvering, theft of players and costly court battles. It even committed the ultimate cardinal sin of capitalism: baseball created a monopoly. This was the backdrop in which the drama of the development of minor league ball was played out. In the 1870s and early 1880s, professional baseball was a mess. Players often jumped to new teams for the promise of higher salaries in another league. There were many independent professional and semiprofessional teams that often paid higher salaries than the Majors. There were even some so-called "amateur" teams that could match the money paid to professionals. Leagues and teams were born and died in the cutthroat atmosphere of business competition. The death of teams generally occurred in a cloud of mystery or under a shroud of corruption. Players were often in transit, and most did not stay on a team for more than a couple of years. Financial backing was always a key issue. When the National League world champion Providence Grays ran into financial trouble in 1885, the whole team was bought by the Boston Beaneaters (Braves) just to get to pitcher Old Hoss Radbourn and catcher Con Daily. All other players were released, and the Grays were no more. College players

# Notes on the Development of the National Pastime

often played on professional teams, and professional players sometimes were hired by colleges to play under assumed names. These players were called ringers. Self-regulation was difficult, if not totally ineffective, and the public often lost confidence.

In 1883, a little order was brought to the scene with the signing of the Tripartite Agreement, which in essence ended the feuding between the National League, the weaker American Association and the powerful Northwestern League. According to details worked out at the Harmony Conference, the National League and American Association would be classified as Major Leagues and the Northwestern League would become the first official minor league. All three leagues agreed to end their squabbles and respect one another's player contracts. Over the next several years, many other minor leagues were formed, including one of local interest—the International League, originally formed as the Eastern League. (It is important to note that as early as 1877 there were informal "minor" leagues, but no formal agreement existed between these leagues and the major leagues, and there was little cooperation.)

The signing of the Tripartite Agreement by no stretch of the imagination ended battling between leagues. Within eight years of the signing, two other major leagues (the Union Association, 1888; and the Players League, 1890) were christened and then met a quick death within a year. Despite the bickering, a strong organizational foundation was created with the entrenchment of the minor-league system. Small towns and cities that could not support a Major League team got what they wanted, players who just wanted a chance to play got what they wanted and Major League owners who wanted to stifle competition and create a decent business climate got what they wanted. The basic formation for professional baseball outlined in the Tripartite Agreement has remained virtually intact to this day.

One might ask: how could railroad, oil and industrial barons be so much in support of competition in business, yet develop a baseball organization founded on the principles of a monopoly? The answer is quite complex; however, a threefold explanation does help simplify this mystery.

## *A Matter of Survival*

Owners, players and fans to some degree all realized that in order for baseball to survive, it must rely on continuity and the momentum of tradition. A lasting sense of community can be gained only when the community can survive long enough to make mistakes and live through tragedies, as well as enjoy exhilarating times. Without tradition, the community upon which the game is built has no glue to hold it together. Baseball connects the lives of

many diverse individuals (players, owners and fans) in a way that allows for differences to be transcended. It is both the common language of baseball and the collective memory of the game and its people that allow baseball to be the national pastime.

## *The Myth*

In my opinion, one can dispel the myth that capitalists want competition. The party line that competition drives capitalism is simply a rationalization that justifies the existence of an economic system. This point should not be thought of in terms of "good or bad"; it is simply a state of being. According to the teachings of Zen, balance is a natural order of things. The balance within capitalism is achieved by the desire to compete and the counter desire to eliminate competition. When baseball tried to live by uncontrolled competition and the lack of order that goes along with that state, it remained a fledgling enterprise at best. Once a monopoly was established, then baseball flourished. This explains how the most aggressive legal system in the world directed at hampering monopolies upholds the right of baseball to maintain one. No one wants to see the Grand Old Game disappear.

## *The West's Infatuation with the Pyramid*

Almost every Western institution, whether it be government, business or community, has a variation of the pyramid model of power. In business, you can always find workers at the bottom of the organizational structure and someone or a group at the top. The U.S. government, in essence, has a triangle of power sitting atop a mountain of political structure below. Our court system is designed in a way that allows mundane legal activities to be settled locally and "important issues" to be settled at the highest level—the Supreme Court. Why should baseball be any different? We must have a top and a bottom. Baseball structure simply follows the laws of organization that are so prevalent in America and most of the world. Serious adult amateur leagues are at the bottom, then comes the minor leagues and finally the Major Leagues, with only one team sitting on top of the hill in October.

By no means does the pyramid of power reflect that the amateur is somehow less important than the professional. In fact, in my opinion, the important folks are the everyday player in the sandlot and the never-say-die minor leaguer who lingers well beyond his prime. One may argue that the paradox that exists between the glory of highly paid professionals at the top and the inequity of the men and women who sacrifice much of

# Notes on the Development of the National Pastime

their young adulthoods to keep playing in spite of the lack of reward at the bottom is simply not fair. The truth is, it's all part of the game. It is not a matter of fair or unfair—it simply *is*. We love the game like no other American sport, past or future, and this love for the game is the fuel that keeps the engine of baseball running.

# Chapter 3

# Women, Rhode Island and Baseball

## *A Short Story*

Unfortunately, the story of women and baseball in Rhode Island is a relatively short one. The role of institutional discrimination, culturally unacceptable activities for girls and women and a lack of opportunity cannot be underscored enough when looking at the history of women's involvement in almost all aspects of baseball. Women's experiences in Rhode Island were not very different from those of women elsewhere in the United States. Women who dared to venture into baseball as a profession found themselves traveling on one of the many dimly lit cultural back roads of our society. Throughout baseball history, many members of the public held such women in contempt, mockery or, at the very least, viewed them as misguided. A much smaller segment of society viewed these women as courageous, daring and adventurous. Despite the odds stacked against them, some Rhode Island women chose to meet the challenge. These trailblazers did not necessarily think of themselves as such. Common among many statements by female players is an attitude that they were simply doing what they wanted to do: play ball. In the following commentary, historic anecdotes of women's experiences in baseball nationally are interspersed with accounts of Rhode Island women to help gain an appreciation of all women's contributions to the game.

In the summer of 1998, when Duluth-Superior Dukes player Ila Borders became the first female pitcher to start in a minor league game, the sporting world was abuzz. This was certainly an amazing feat. But long before, pioneering women provided a foundation on which today's ball-playing women now stand. No one knows when women first started to play baseball; however, history is heavily sprinkled with evidence of such aspirations.

# Rhode Island Baseball

## The Bloomer Girls

The first recorded duel between two all-female teams was reported by the *New York Clipper* to have taken place in Springfield, Illinois, on September 11, 1875. Promoters billed the teams as the Blondes versus the Brunettes. By the mid-1880s, women's baseball teams were a bona fide fad. By the 1890s, several colleges had women's teams (the first all-female college team was organized by Vassar College in 1866), and mixed-gender "pickup" games were not uncommon. Although college-level competition did not survive, the 1890s and early 1900s saw the development of many professional-level teams that were composed mostly of women. The teams were called Bloomer Girls after their style of uniforms. Bloomer Girl teams carried two to three male ballplayers who generally dressed up in bloomers as well. Two of the more famous of these male players included a skinny teenager named Joe "Smokey" Wood and an aging hurler, Grover Cleveland Alexander. Both were subsequently elected to the Hall of Fame.

The first involvement of women playing professional baseball in Rhode Island found in research to date was a Bloomer Girl team from Chicago. The *Providence Journal* carried the results in the July 28, 1902 edition of the morning paper. The headline read: "'Girls' Were Out to Win Game. Centerdales and Chicago Stars Fought Nine Innings Before Large Crowd." The Chicago Stars were a traveling Bloomer Girl team that represented the talent and professional level that women's team had developed from stiff competition in the 1890s. The all-male semiprofessional Centerdale Nine was surprised by the Stars' play, barely squeaking out a ten to nine victory. The primary purpose of Bloomer Girl teams was to entertain and make money. Whether purposeful or not, the teams also were championing the cause of women's sports by changing the attitudes of spectators, as demonstrated by the following excerpt from the *Providence Journal* news account of the game.

> *Yesterday afternoon was cloudy and threatening rain, but this did not hinder more than 4000 persons from seeing the ball game at Rocky Point between the Centerdales and the bloomer girl team called the Chicago Stars. Evidently, they saw another cherished tradition, that women cannot throw straight, or hit anything she aims at, go the to "damnation bow-wows," so to speak, for the girls in bloomers proved beyond a doubt that some girls can throw over to first as well as some other members of their sex can throw over their friends, and several of the stellar bunch managed to get the stick at the proper point of juncture with "Crythy" Taylor's curves, although*

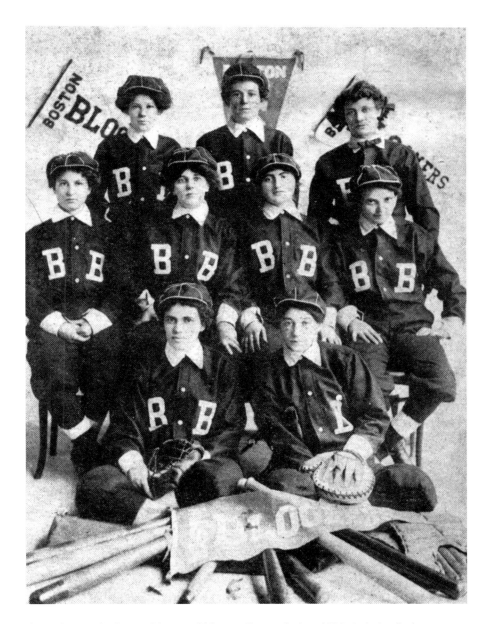

A rare image of a Boston Bloomer Girl team. Postcard, circa 1906. *Author's collection.*

# Rhode Island Baseball

*the burden of batting for the fair ones in bloomers was bourne by two male members of the team, who played at short and behind the plate.*

The excerpt above not only provides a backhanded compliment to the women of the game, but it also displays the "prudish" attitude toward women athletes that was common at the time. No doubt women were playing ball in Rhode Island a lot sooner than 1902; however, their exploits were not readily put into print. Bloomer Girl teams toured Rhode Island through the 1920s, but they weren't the only touring teams to include women. The House of David, a traveling evangelistic baseball team known for their long, uncut hair and beards, and another touring team, the Pittsburgh Hoboes, both used female players. In fact, in 1933 both teams appeared in Woonsocket, boasting two of the greatest female players in history. The House of David had Jackie Mitchell and the Hoboes played Harriet Smith. Both women were under professional contracts with minor league affiliates.

## The First Female Professional Ballplayer

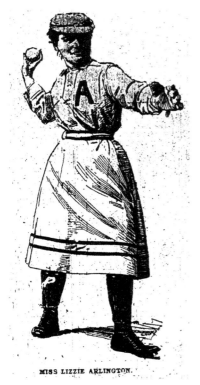

MISS LIZZIE ARLINGTON.

Mitchell and Smith weren't the first women to sign on the dotted line with a professional team. That honor goes to one Lizzie Strider (playing name Lizzie Arlington). According to researcher Barbara Gregorich, the *Philadelphia Inquirer* reported that Arlington was paid $100 a week to pitch in semiprofessional games by theatre promoter Captain William J. Conner. Later, Conner convinced Atlantic League President Edward Grant Barrow to sign Arlington to a minor league contract. She pitched in a game between Reading and Allentown on July 5, 1898, making her the first woman to play in a minor league game. She did not play in another professional game and was later released by Connor.

Liz Arlington. Philadelphia Inquirer, *July 21, 1898.*

# Women, Rhode Island and Baseball

## Romantic Promise and Promotion of the Game

Unfortunately, the use of women in a manner that emphasizes romantic allure to promote products is not a modern phenomenon. It has been with "mankind" since the beginning of culture. Baseball took full advantage of this avenue of promotion. The two postcards in this section demonstrate clearly to young men of the time that baseball and romance were closely tied.

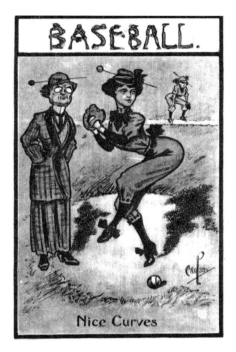

*Above left*: Although this card is dated 1908, the artwork most likely originated in the 1890s, given the attire and the fact that the umpire is standing behind the pitcher as opposed to behind home plate. The picture is clearly degrading to women in general; however, it also has a few other disturbing features. The women are scantily clad for the times, but the umpire is dressed in respectable attire. If you look closely at the umpire's face, you find a grotesque expression, reminiscent of Halloween. These features are reinforced by the typeface used and the "scary"-looking hairpins. The last odd feature is that the woman pitching does not even appear to have a ball in her hand, as evidenced by the ball on the ground in front of her. The moral of this "picture story" is: if you are a woman and choose to play baseball, you are not only incompetent in the game, but are open to being viewed as a sex object, suffering the wrath of society. *Author's collection.*

*Above right:* The message here is: the ball players get the girl. Postcard, 1910. *Author's collection.*

Besides promoting romantic pleasure through their participation in baseball, women were used as a "drawing card" to games. Beginning in the late 1870s, promoters often charged no admission or reduced rates for "ladies." Special sections were sometimes devoted to the seating of the "fairer sex." Throughout the 1880s, the numbers of women attending the game were recounted in postgame write-ups in the local press, and the games were often praised for being played in a "gentlemanly" fashion, even though descriptive accounts indicated otherwise. The general thought was: the more young ladies attending a game, the more paying young men would attend. The constant portrayal of women's role in baseball as being either of a romantic nature or as "drawing cards," and the overbearing "fatherly" disapproval of baseball as not being a women's sport, combined to make "real participation" in baseball a very difficult and overbearing task for many women. One Rhode Island woman, however, not only overcame these barriers, but also made a good living playing the sport.

## Lizzie "Spike" Murphy

Rhode Island's "first lady" of baseball was Warren native Lizzie Murphy. Born to millworker parents in 1894, Lizzie was playing semiprofessional ball by age fifteen. As a youngster, she played baseball, hockey, soccer and other sports. By all accounts, she was a hard-nosed, gritty ballplayer who was able to hold her own against all male comers. She threw accurately and seldom swung at a bad pitch.

According to the late sports columnist Dick Reynolds, Lizzie's baseball activities weren't so much to promote women's rights as due to her passion for the game and her desire to stick up for her own rights. Reynolds related a story about her baptism into the semipro circuit in 1914. Lizzie was signed to play on a local semipro team. Her presence drew the largest crowd of the season. After the game, Lizzie asked for her gate share, at which time the manager refuse to give her any money. Lizzie waited until the following week, when it was time to board a bus to play a second game in Newport. She refused to board unless she would be rewarded her proper share. After careful consideration of what would happen once testy Newport sailors came to the game to watch a woman play and found that she wasn't there, the manager relented and agreed to pay her five dollars a game plus an equal gate share.

Lizzie pioneered many Rhode Island baseball firsts for women. Following are two of the most significant:

# Women, Rhode Island and Baseball

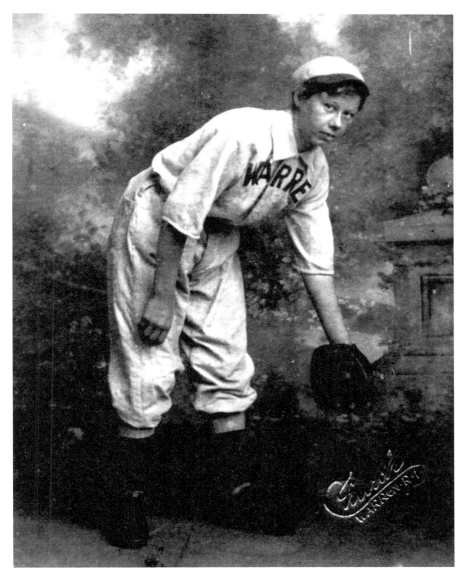

A postcard sold by Lizzie Murphy after ball games, circa 1912. *Author's collection.*

1) She was the first woman to play in a Major League exhibition game. The game took place on August 14, 1922, and was between the team she owned, the American League All-Stars, and the Boston Red Sox at Fenway Park. Lizzie didn't play much, but she made good use of her time, earning the approval of her Major League teammates.

2) She is said to be the first woman to have played for an all-black team, the Cleveland Colored Giants (1929) at Rocky Point. She held her own.

Lizzie accomplished much in her twenty-five-year baseball career. Not only did she support herself playing on semiprofessional teams (including the famous Carr's All-Stars), making fifty dollars a game, but she also owned her own team for a short period. She retired at age forty with a career batting average of just under .300 and a reputation for playing very dependably at first base. At the age of forty-two, she married Walter Larivee, a local Warren mill superintendent. After he died seven years later, she remained self-sufficient, doing millwork and working in the shellfish industry. Elizabeth M. "Lizzie" Murphy died in 1964 at the age of seventy, having lived a most unusual and adventurous life.

## THE ALL-AMERICAN GIRLS PROFESSIONAL BASEBALL LEAGUE

The controversial sports question of 1952 was presented on the cover of the August 10 edition of *Parade* magazine: "Do Girls Belong in Pro Baseball?" The article inside seemed to indicate that middle America thought not. Indeed, by the end of 1954, professional women's baseball abruptly ended. The original question that was raised in 1898 by Liz Arlington and carried on by Smith, Mitchell, Murphy and others ceased to exist—until recently. However, before that question went into hibernation, five Rhode Island women addressed the question and did so in style. They were card-carrying members of and players in the All-American Girls Professional Baseball League. Rhode Island's contribution to the league included Louise Arnold, Wilma Briggs, Anita Foss, Barbara Liebrich and Marilyn Jones.

The All-American Girls Professional Baseball League (AAGPBL), popularized by the movie *A League of Their Own*, was the brainchild of Chicago Cubs owner and gum magnate Philip K. Wrigley. In 1943, Wrigley formed the AAGPBL as a form of entertainment and as a way to boost morale during the war years. Women's roles in America were changing rapidly as they took over many of the jobs vacated by men who went off to fight overseas. Evidently, the job of baseball was no different in this regard. The development of the league spawned the greatest opportunity for women in professional baseball since Alexander Cartwright penned the rules of the game in 1847.

On the following pages are short career sketches of the five Rhode Island women who played in the AAGPBL. Each of the five women played for

## Women, Rhode Island and Baseball

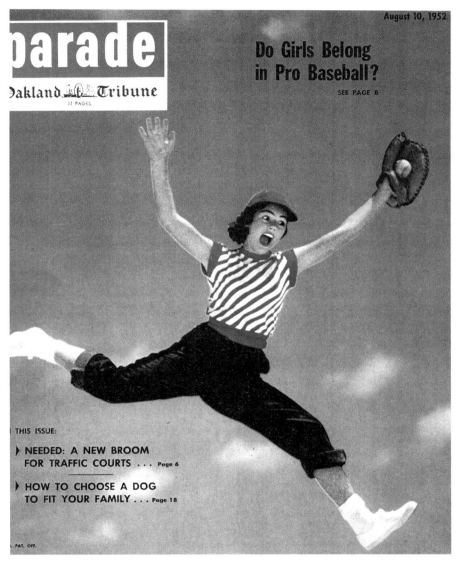

As women continued to play in the All-American Girls Professional Baseball League, establishing an expanded role for women, America was struggling with the gains women made during World War II in terms of ability to perform work previously reserved for men, economic independence and expanded roles outside of the traditional family. In some ways, the question raised on this cover of *Parade* magazine simply reflected the conflicts within society. August 10, 1952. *Courtesy* Parade *magazine. Author's collection.*

one or more highly competitive softball/baseball team(s) prior to playing professionally. Rhode Island's AAGPBL players' paths were similar to my mother's early experience. My mother, Katie "Home Run" Hudson, played for her hometown Maxwell, Iowa team from 1945 to 1948. Although she was offered a tryout with the AAGPBL in Chicago, she declined. As a hard-hitting third baseperson, Katie helped her team win many games with the long ball. The story of "Home Run Katie" was unknown to me until two weeks before her death in 1999, when she pulled me aside to reminisce and tell me how proud she was that I was writing baseball history books that explored the influence of the game on communities. My mother taught me and all my siblings how to bat, and we knew she was good, but we never realized just how good she was.

## Louise "Lou" Arnold

*Born: May 11, 1923, in Pawtucket, RI*
*Height: 5' 3"*
*Playing weight: 125 lbs.*
*Position(s): pitcher*
*Team(s): South Bend Blue Sox, 1948–52*
*Batted: right*
*Threw: right*

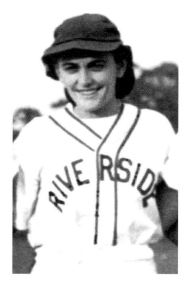

Lou Arnold, circa 1945. *Courtesy Wilma Briggs.*

Louise Arnold, like many of the AAGPBL professional players, learned her craft by playing softball. During her five-year career, Louise was involved in many important games. She had a one hitter to her credit and helped pitch her team to two championships. Her best year of pitching was 1951, when she went ten and two for a .833 winning percentage and sported a 2.62 earned run average (ERA). Louise had fun with the teams on which she played, as indicated by her file at the Baseball Hall of Fame, where the following tribute may be found:

> *Lou's pixie like sense of humor and dugout antics are what her teammates attribute their playing loose enough to win the League Championship in 1951.*

# Women, Rhode Island and Baseball

In a personal interview, Lou stated (with heartfelt emotion) that one of the greatest moments in her life was when the Baseball Hall of Fame honored the women of the All-American Girls Professional Baseball League. During the interview it became very obvious that having an opportunity to play professional baseball has had a significant effect on the rest of her life, providing her with rich and wonderful memories and experiences. After leaving baseball, Louise was employed by the Bendix Corporation in South Bend until her retirement forty years later. Here is a good trivia question: why did Lou Arnold always wear the number thirteen on her uniform during her professional career? Answer: she was born the thirteenth child in her family.

## WILMA "WILLIE" "BRIGGSIE" BRIGGS

*Born: November 6, 1930, in East Greenwich, RI*
*Height: NA*
*Playing weight: 138 lbs.*
*Position(s): outfield, first base*
*Team(s): Fort Wayne Daisies, 1948–53; South Bend Blue Sox, 1954*
*Batted: left*
*Threw: right*

Frenchtown Farmers Team, circa 1946. It is not hard to figure out which one of these players is Wilma Briggs. *Courtesy Wilma Briggs.*

Wilma Briggs began playing baseball at a very young age. By the time she was a teenager, she was playing for her father's team, the Frenchtown Farmers. In high school she played on the boy's varsity baseball squad. She credits her baseball skills to the coaching she received from nineteen-year Major League veteran Max Carey. Wilma's skill was evident in both her defensive and offensive performances. In 1951, she led the league in defense at her position of outfield with a fielding percentage of .987. She finished her career with the third highest number of career home runs: forty-three.

Over the course of the AAGPBL development, many changes were made to make the game more like professional men's baseball and less like women's softball. The biggest change was the size of the ball, one that came in the last year of the league, 1954. Originally, the ball was eleven inches in diameter, the same as a softball. Later, the diameter was changed to ten inches. Because a larger ball can not carry as far as a regulation hardball, many AAGPBL players advocated for a regulation nine-inch Major League ball. In July 1954, the league adopted the official Major League ball. Given this opportunity, Wilma, who had always been a power hitter, adapted very quickly. Before the appearance of the new ball, she had hit only three home runs that year. From July 1954 to the end of the season, she hit twenty-two more, resulting in a second-place finish for the most home runs hit in the league that year. Of special consideration is the fact that her twenty-five home runs were hit in regular-size professional stadiums and in only 317 at-bats. To put these numbers into perspective, most Major Leaguers get up to bat about 500 times a season. If Wilma had been given the opportunity of 500 at-bats, she would likely have hit around thirty-seven home runs, and if the regulation ball had been in play from the beginning of the season, her home run total could have easily exceeded fifty.

After retiring from baseball, Wilma earned a bachelor's degree and taught elementary school for twenty-three years. She received several significant honors connected with baseball in her lifetime, including being the first woman to be inducted into the East Greenwich Athletic Hall of Fame, receiving the first annual Game of Legends Award for thirty-eight years of contributing to Rhode Island's Women's softball and being elected to the first All-American Girls Professional Association board of directors. One of her greatest honors, according to Wilma, was playing for Hall of Fame member Jimmy Foxx.

# Women, Rhode Island and Baseball

## ANITA "NITA" FOSS

Born: August 5, 1921, at Providence, RI
Height: 5' 2"
Playing weight: 118 lbs.
Position(s): pitcher, second base
Team(s): Springfield Sallies, 1948; Muskegon Lassies, 1948–49; Rockford Peaches, 1949
Batted: right
Threw: right

According to information filed in the Baseball Hall of Fame, Anita decided to try out for the AAGPBL after being notified by the navy that her husband had been killed in action. In relation to her husband's death, she commented in W.C. Madden's book, *The Women of the All-American Girls Professional Baseball League*: "That was the right kind of medicine to get away."

According to all accounts, Anita was known to be a "scrappy hitter" after she learned to hit the curve ball and was an "all around good fielder," playing second base. She had a short career, but tried her hand at pitching on two teams. After her baseball career, she pursued work at Douglas Aircraft and became the first woman supervisor in her department.

Anita Foss, circa 1945. *Courtesy Wilma Briggs.*

## BARBARA "BOBBIE" LIEBRICH

Born: September 30, 1922, at Providence, RI
Height: 5' 9"
Playing weight: 145 lbs.
Position(s): second base, third base
Team(s): Rockford Peaches, 1948; Springfield Sallies, 1949 (player, manger and chaperone)
Batted: right
Threw: right

Barbara Liebrich, circa 1945. *Courtesy Wilma Briggs.*

Barbara's father was a well-known pitcher and must have passed the love for the game on to his daughter. After graduating from high school, she played for several good softball teams, including the Monowatts, UNCAS, Auburn Royals and, of course, the Riverside Townies. Barbara sparkled on the field of play and was offered an AAGPBL tryout in New Jersey. She remembers the tryout being held in a large armory and also recalls that Max Carey was in attendance. Barbara performed well enough to be signed to a contract for $125 per month. (The monthly salary was about $25 more than a newly signed minor league male player would have received at the time.)

Life on the AAGPBL circuit involved a great deal of travel and offered few amenities. According to Barbara, the women were put up in hotels, had strict curfews and were held to a high behavior standard. While on the road, each player received three dollars a day for meals. When playing at home, the players were put up in local homes that took in boarders. Several of the AAGPBL players whom I interviewed stated that they felt the host families were very important in helping them adjust to their new lives. Barbara enjoyed the places in which she played, not just during the season, but also during spring training. In the early years of the league, spring training was held in Cuba and was later moved to Florida. The teams continued to play exhibition games in Cuba, however, and Barbara recalls playing with a number of Cuban-born players at these games.

One fond memory Barbara related was from a visit to Yankee Stadium. She recalls meeting with Yankee broadcaster Mel Ott, future Hall of Famer Yogi Berra, the great Connie Mack and both of the Dean brothers, Dizzy and Paul. She particularly enjoyed talking to Dizzy.

Although Barbara's career as a professional was short, her involvement in the league spanned several years. She was a player, manager, chaperone and played on the traveling goodwill league team. Barbara was a spokesperson for the league, and while on tour, her goodwill team (which she managed) acted as "ambassadors" for the AAGPBL. She ended her career as a chaperone for the Kalamazoo Lassies. After baseball, Barbara became the office manager of a large printing firm.

## Marilyn C. "Jonesy" Jones

*Born: April 5, 1927, at Providence, RI*
*Height: 5' 5"*
*Playing weight: 135 lbs.*
*Position(s): catcher, pitcher*

# Women, Rhode Island and Baseball

*Team(s): Fort Wayne Daisies, 1949; Chicago Collens, 1949; Rockford Peaches, 1950–51; Battle Creek Belles, 1951–52; Muskegon Belles, 1953; Fort Wayne Daisies, 1954*
*Batted: right*
*Threw: right*

Marilyn Jones, circa 1945. *Courtesy Wilma Briggs.*

Marilyn Jones (Doxey) holds the honor of being Rhode Island's best pitcher in the AAGPBL, although she did not start out at that position. Having honed her baseball skills with the Monowatt Electric Company and the Riverside Townies, she successfully tried out for the AAGPBL in March 1948. After spring training in Opa-Locka, Florida, she was signed by the Kenosha Comets. In her first season, she failed to hit well and played backup catcher. Throughout her career, she continued to struggle at the plate and finished with a .158 batting average.

Fortunately for Marilyn, while playing for the Battle Creek Belles she was asked to start a game for an injured starting pitcher. She did well enough to start a second game, in which she no-hit her former team, the Daisies, and her pitching career took off. She finished 1952 with a nine and seven record and a 1.69 earned run average (ERA). Marilyn continued to pitch until the league folded after the 1954 season, and she sported a career record of thirty-one wins, twenty-six losses and an ERA of 2.79. She remains the only Rhode Island woman ever to have pitched a no-hitter in a professional baseball game.

## Perhaps…

Perhaps this story is not as short as it was thought to be in the beginning. However, there is no doubt that in comparison with the male gender, Rhode Island's story of women's baseball is not as long as it should be. Today, there are many young girls who enter Little League, but only a few remain at the senior level of play. There is no viable evidence that indicates

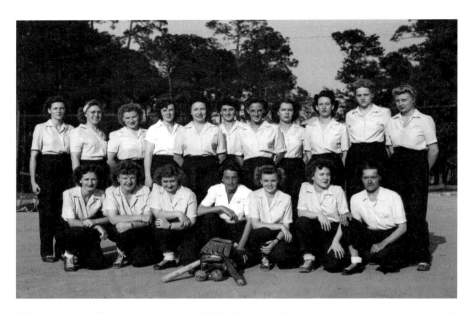

Women's Army Corps baseball team, 1943. Like it was for their male counterparts, baseball was part of army camp life for women who had volunteered for the United States Women's Army Corps. The corps was created in 1942 as the Women's Army Auxiliary Corps. The name was changed in 1943 at the time this photo was taken. Although a noncombat unit, the corps provided vital wartime services in personnel, intelligence, training, supply support and administration. *Author's collection.*

that women do not possess the necessary skills to continue to play at all levels of baseball. So, our story ends with a question: why are there not more women represented in baseball at all levels of play today?

CHAPTER 4

# THE SOLDIERS' PASTIME

Perhaps no institutions were more responsible for the spread of the national pastime to all parts of the United States than those of the U.S. Armed Forces. Wherever large groups of people amass for an extended time, one will always find some form of organized recreation. For many years in the army and navy, the primary organized recreation was baseball. Because baseball is the "national game" and was well-known throughout the country, it had a way of culturally unifying soldiers from all parts of the country as no other activity could. Whenever the country was engaged in hostilities, the game was used to maintain morale in training camps, as well as at the front, and many camps recruited professional and semiprofessional players for their teams.

## IN THE BEGINNING

The relationship between baseball and the military has an extremely long history originating at the birth of our nation. There are memoirs of veterans from the Revolutionary War who wrote of playing "ball" (probably a form of town ball) at Valley Forge. During the Civil War, the game was introduced to many Union soldiers who had come from points out West and had not yet become familiar with the game of baseball that had originated in New York and New England. Many Confederate soldiers learned the game from Union prisoners. In both cases, the game was brought back to every backwater nook and cranny in rural America.

During the formative years (1850–80), baseball proliferated in many cities throughout the East and as far west as Cincinnati. As the game wove its way into the fabric of our society, it also appeared throughout the military

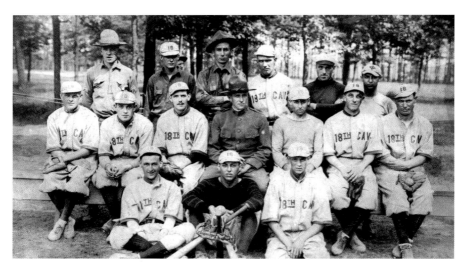

The Eighteenth Cavalry, Fort Ethan Allen, Vermont, 1917. *Author's collection.*

branches. The USS *Maine*'s baseball team won the North Atlantic Squadron Championship of 1898. The fact that there was a "championship" series involving a squadron in the navy illustrates the level of popularity the game enjoyed in the military at that time.

## THE GREAT WAR (WORLD WAR I)

During the early 1900s, baseball gained unprecedented growth in popularity, producing such colorful characters as Ty Cobb, Honus Wagner, Mordecai Centennial "Three Finger" Brown, Nap Lajoie and many more. The period saw the solidification of the National League, the development of the American League and the birth and death of the Federal League. The fledgling minor league system of the 1890s flourished and grew in the second decade of the twentieth century. The world, however, was not stable. While the United States and its national pastime were being nourished by the Age of Discovery, Europe was a powder keg of political turmoil waiting to burst. In 1914, it did, resulting in the Great War. America began to feel the war's pull in 1917. By 1918, the United States was fully engaged, and so were most of the ballplayers from the professional, semiprofessional and amateur ranks. It was a patriotic war, and many players were drafted or enlisted. Those who did not answer the call to duty were directed by Secretary of War D.J. Baker

# The Soldiers' Pastime

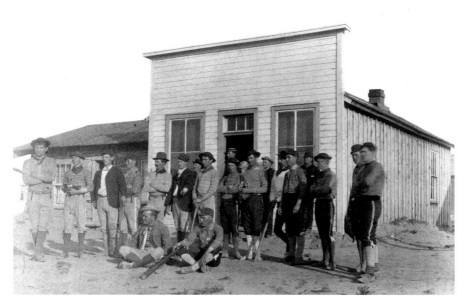

A Western U.S. Cavalry Post, circa 1880. *Author's collection.*

to work in war defense industry jobs, and the minor leagues all but ceased to exist by July 1918. (Players who did not go to war were paid handsomely by their employers to play ball on war industry factory teams.)

A total of 227 Major Leaguers served in the armed forces, including Hall of Famers Branch Ricky, Ty Cobb, George Sisler and Christy Mathewson. World War I took the lives of three Major Leaguers who were killed in action. Many others were injured, including Mathewson, who would die in 1925 as a direct result of exposure to mustard gas during a wartime training exercise. Meanwhile, baseball's popularity within the armed forces soared, both on the homefront and abroad.

## Teddy Roosevelt, Frank Gilmore and the Second Naval District Baseball Club

By 1917, Newport was being inundated by a never-ending tide of sailors training at the city's two navy stations. Tension was at an absolute high early in 1918. These tensions did not go unnoticed by one of Newport's favorite

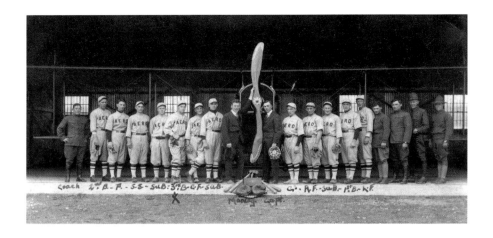

Aviation baseball team, 1917. The average life expectancy of an aviator in World War I was three weeks. Baseball helped alleviate the stress associated with grave danger. *Author's collection.*

visitors, ex-president Theodore "Teddy" Roosevelt. To help mediate these tensions, Roosevelt established a baseball team, the Second Naval District Baseball Club, which was composed of sailors from the United States Navy Submarine Base in Newport. The navy hired ex-Major Leaguer and Newport native Frank Corridon to coach and manage the team. The Second Naval District team turned out to be very, very good, defeating most opponents it played. The team battled the minor league Providence Grays, Boston College, Brown University, Princeton, the National League New York Giants, West Point, Camp Devens and Fort Adams, as well as local mill teams.

Among the ballplayers was a young, scrappy submariner and native Rhode Islander named Frank Gilmore. Gilmore had played in the Connecticut State League in 1915 and was a member of the Providence Grays in 1916. When Gilmore enlisted in the navy in 1917, he expected to see action in the upcoming war. According to his grandson, John Gilmore, this never came to be. He was assigned to the submarine base in Newport, and when Teddy Roosevelt started the Second Naval District Baseball Club, he was immediately nabbed to play right field. Like other team members at the base, he never saw action during the war.

Following Gilmore's discharge from the navy, he settled in Johnston and began working at the Centerdale Worsted Company. It wasn't long before he started playing on the mill's team and immediately became its star player. After a couple of seasons, he was paid a good salary and no longer had to

work much in the shop. His job? Pitch every Sunday. Baseball wasn't the only "game" he played, however. He was such a celebrity that he started to develop business contacts at the games. When Prohibition was lifted, he started a liquor-distributing business and became quite well off. According to John Gilmore, his grandfather's home was frequented by many Major League players and the "who's who" in Rhode Island baseball. One of Frank's brothers, John, played in the minor leagues with the Fort Wayne and Pawtucket teams from 1914 to 1915.

During the 1920s and '30s, baseball continued to be a mainstay in the scaled-down military branches. But the teams failed to have the excitement and glamour that Major League players brought to the game during wartime. In many ways, the game mirrored the backyard/sandlot game of small towns across America that were simply backdrops to the daily activities of life. The national pastime, however, absolutely and always reflects the ebb and flow of American history. Like the previous war spawned in Europe, the new war developing in the East and West would have a profound effect on the Grand Old Game in the armed forces, as well as on the homefront.

## WORLD WAR II

### *The Homefront*

Early in World War II there had been talk of suspending baseball until the war was over. But after careful consideration, politicians and baseball officials decided it was better for the country's morale to keep playing. The war effort, however, did not leave minor league baseball unscathed. From the turn of the century through 1940, minor leagues had grown extensively. Even with the sharp economic downturn due to the Great Depression in the 1930s, during which many leagues went out of business, there were still forty-five organized leagues in operation as of 1940. By 1943, however, there were only ten minor leagues left. In the vacuum created by the failing minor league system, semiprofessional leagues like the New England Victory League were formed.

The New England Victory League (1941–45) comprised various teams from around southern New England, including the Rhode Island entries: Cranston Fire Safes, Woonsocket Marquettes and Pawtucket Slaters. The league flourished, attracting large crowds in every ballpark. As an added attraction, many Major Leaguers played under assumed names on these teams. One Cranston player in particular stands out—Joe Canuso. This young, future–Hall of Fame Yankee catcher played for the Fire Safes in 1945.

Inscription on back: "Baseball in Guantanamo. W.S.S. *Delaware* rig up deck so pitchers, batsmen, & catchers can get practice—Getting ready for the Atlantic Fleet Championship." Stamped 1922. *Photo by Paul Thompson. Author's collection.*

His real name? Yogi Berra. New England Victory League teams not only played one another, but they also played military outfits form Fort Devens, the Coast Guard and the Sea Bees, as well as war industry plants like Central Falls's Walsh-Kaiser Shipbuilders. (The league transformed after the 1945 season into the professional Class B New England League.)

In almost all respects, semiprofessional leagues like the New England Victory League were equal to lower-level minor leagues. Most players received a monthly salary of $100 to $150, which equaled Class D minor league salaries after the war. Press coverage was equal to that of the minor leagues, and attendance was very similar. This brand of baseball certainly provided an excellent diversion to the war and gave youngsters a sense of normalcy.

## Prisoners of War

Some prisoners of war were allowed to bring the game to their dreary surroundings. In a heartfelt plea, one *Cranston Herald* columnist asked for

citizens to help the imprisoned soldiers by donating baseball equipment and other sporting equipment to be distributed to prisoners abroad via the Red Cross. While baseball was being played in army camps throughout the East and West arenas of battle, American prisoners of war managed to squeeze a little enjoyment into their lives by engaging in their own version of sandlot baseball.

## Knocked off the Pedestal

Baseball always had its organized sports rivals when it came to occupying the recreational activities of military personnel. Football, boxing and, in later years, basketball were all present, but baseball held its number one position through most of our nation's history. Gradually, however, baseball moved into the shadows. The fading of the sport's importance roughly paralleled the fading of organized adult amateur and semiprofessional baseball in our communities and places of work after World War II. Very significant changes occurred to the game on the professional level, and on all other levels, after the war. In a roundabout way, baseball in the military was not only influenced by these changes, but was an associative factor as well. By 1960, baseball in the military was a mere shadow of what it once had been.

## Chapter 5

# Who Killed the Dead Ball?

One might ask: is it legally possible to kill something that is already dead? In the case of the "dead ball," it would seem that indeed it is. To understand this phenomenon, we must first look at the characteristics of the victim, which in this case is the early version of the baseball.

## Dead Ball Vital Statistics

*Age: over 100 (date of birth not known; date of death between 1900 and 1910)*
*Circumference: varied 9–11 inches*
*Vital characteristics: horsehide cover, wound yarn middle*
*Weight: varied 5½–9¼ ounces*
*Family ancestry: balled hide and sinew, fabric and yarn, wound yarn and string*

In its infancy, baseball preferred a softer "dead" ball. Baseball gloves were not in use, and in the game's earliest forms, one could hit the runner with the ball to get him out. High scores were common, and there were many misplays that were considered part of the game. The game as a whole was more compact in style. The dead ball contributed immensely to maintaining these and other early traditions of the game. It was also a time when funds were sparse, requiring a fair amount of ingenuity by the players, who sometimes created their own balls. Manufacturing techniques did not lend themselves to the development of a livelier ball either. For all of the above reasons, players were satisfied for many years with the dead ball.

As the fans became more intrigued by the game and demanded more action, the concept of "offense" gradually came into play. With the advent of the "enclosed" ballpark, which allowed admission to be charged, came

"Dead Ball." Postcard, circa 1900. These friendly looking undertakers appear to be getting ready to put an end to the "dead ball era" of baseball. *Author's collection.*

the phenomenon of the home run. It did not take long for fans to appreciate a player who had the ability to "knock it over the fence." However, traditions die hard, and owners and equipment manufacturers were slow to come around. In the 1890s and early 1900s, some sporting goods companies began to advertise balls that had a rubber center or cork center, both of which definitely made balls much livelier. Within the first decade of the twentieth century, Spaulding had perfected a cork-centered ball that became the focus of the first "juiced up ball" controversy. The new ball was introduced in the Major Leagues in 1910. Home run tallies climbed with the use of the ball, from 271 in 1909 to 359 in 1910 and 512 in 1911. The home run craze was on. It did not take long for the demand to overshadow tradition, and by 1912 no dead balls could be found anywhere, except perhaps in the most rural of sandlot games.

## So Who Murdered the Dead Ball?

Besides hitters like Home Run Baker, Sherry Magee, Gavvy Cravath and Vic Saier, it would seem that *we* were the murderers—or at least our distant relatives. Fans demanded the excitement of the home run. Without the home run, there would have been no King of Swat or Mr. October, and

# Who Killed the Dead Ball?

perhaps no Bernie Carbo. (You've got to be a Red Sox insider to understand the mention of Bernie's name here.) We the fans made possible the demise of the dead ball, and it will remain gone and buried forever. May it rest in peace.

## "Mama's Boy!" Jeered the Crowd. "Men Don't Wear Gloves!"

In the early days of baseball, gloves simply were not in use. One could always tell a catcher on the team by his gnarled-looking fingers, caused by multiple sprains and broken bones. Another side effect of barehanded fielding was the number of errors, resulting in high-scoring games, some of which exceeded one hundred total runs with more than fifty errors.

So when did the first glove come into use, and what changed player attitudes toward the use of gloves? The first recorded use of a glove was by Doug Allison, who caught for the Cincinnati Red Stockings in 1869. Although Allison was certainly a popular player, his influence in this area was minimal. There was not another glove used until 1875, when Charles Waitt of St. Louis sported a glove similar to those used by buggy drivers. According to historian Jim Thorn, Waitt received quite a razzing by fans and players alike for his "unmanly" conduct. As would be expected, image-conscious players did not gravitate toward using gloves.

It was not until the early 1880s, when the overhand pitch was allowed, that gloves became prudent for catchers and fielders alike. An overhand pitch can be thrown much harder than an underhand pitch, a fact not lost on catchers. Buck Ewing, catcher for the New York Giants, became the first player to wear a padded mitt. Other

"I wish someone would get around to inventing the baseball glove!" Harper's Weekly, *Saturday, June 22, 1889. Author's collection*.

catchers followed suit. Fielders soon became dramatically aware of Newton's third law of physics, which states, "For every action, there is an equal and opposite reaction." There is no greater demonstration of truth for this law than the result of a batsman connecting with a high, hard fastball. Any baseball player will tell you: the faster the pitch, the harder the hit. Fielders soon caught on to this realization. It did not take long for specialty gloves to be developed for each fielding position. By 1900, gloves were all the rage, and all basic models had been developed. As time went on, webbing and more padding were added, and gloves also got much bigger. More finger pockets were added, too.

## Why Baseball?

### *Why Not Rounders or Town Ball or Any Other Name?*
Let us consider the origins of the term "baseball." There are thirty-seven definitions for the word "base" in *Webster's Dictionary*. The ninth definition provides us with the best clue: "that from which a commencement, as of action or reckoning, is made; starting point or point of departure." Think about it. Almost all offensive action in baseball either starts or ends in relation to a base. So, when folks started to use a rock or "stuffed sack" as a place of "safety" for a runner, the use of definition number nine must have seemed appropriate.

Now that we have established a plausible theory on the use of the word "base," what about the use of the item itself? Why not a goal or wicket (as in cricket) or a four-foot stake (as used in the Massachusetts game)? If it had not been for a quirk of fate, perhaps we would be playing "stake ball" today. (Of course injuries would be much more prevalent.) For those of you who crave clear-cut answers, the one proposed in this book will be somewhat inadequate. The only viable answer to the above questions lies in understanding the process of cultural evolution. In essence, there is not one answer, but scores of answers, some known and some not known. What makes one sport more popular than another or one version of a game more acceptable? Why not goal ball, town ball or rounders? All three were popular games when "base ball" came into play. The answer is composed of factors influenced by fate, luck, historic events, ethnic inspiration, economics and individual personalities. These are the same factors that so greatly affect cultural development. Since baseball is a cultural development, it must follow these same rules of development.

# Who Killed the Dead Ball?

## THE LOUISVILLE SLUGGER

### *What Are the Origins of the Most Famous Bat in the World?*

The original Louisville Slugger was turned out on a lathe by eighteen-year-old "Bud" Hillerich in 1884 in Louisville. He made the bat to order for Pete Browning of the Louisville Eclipse team. Ol' Pete hit .341 in his thirteen Major League seasons, and his bat became well-known in baseball circles. It was not long before many professional players were ordering their bats from Hillerich, who registered the trademark "Louisville Slugger" in 1894. Today, Hillerich and Bradsby produces over 1.5 million Louisville Sluggers a year for players from the minor leagues to the Majors. The most famous bat in Rhode Island, although not known by many, would be that of Charles Basset, who, prior to turning professional for the National League Providence Grays in 1884, attended and played at Brown University. In 1883, his last year at Brown, he batted .448. Bassett burned the number .488 into the barrel of the bat and used it as a professional in 1884. The bat disappeared when an emotionally erratic pitcher, Charley Sweeney, became angry during a game and threw it over the fence. The bat was never seen again.

Rhode Island also had its own bat-manufacturing company at one time. According to an advertisement posted in the *Providence Evening Bulletin* in 1876, the Providence Bat Company was producing high-quality bats for sale to all interested parties. At the time of this writing, research has not turned up any more information about the Providence Bat Company, but the search continues.

## POSTSCRIPT

### *One Last Mystery*

Question: Why is the pitching rubber 60½ feet from home plate?
Answer: The distance of the pitching rubber was moved from 45 feet to its present distance in 1893 due to hard-throwing Amos "The Hoosier Thunderbolt" Rusie's overhand pitching. The rubber was originally intended to be 60 feet from home plate, but an error in the handwritten instructions inadvertently added six inches. It has been 60½ feet ever since.

# Chapter 6

# Historical Notes

## 1827–1870

### The Beginning

Rhode Island ranks among the earliest states to embrace the game of baseball. As discussed earlier in this book, baseball's roots most likely go back to early forms of English games. Throughout New England, including Rhode Island, some rudimentary form of baseball was played as early as the 1770s. Regular newspaper accounts of the game are rare nationally prior to the 1850s and did not begin to show up in Rhode Island until the early 1860s. Historian George A. Thompson of New York has located a reference to the game in 1823, and as mentioned previously there was a reference to baseball in 1825 published in an Upstate New York newspaper. Rhode Island's entry into the "written reference sweepstakes" comes from a Brown University student's diary. Williams Latham wrote in his diary on March 22, 1827: "We had a great play at ball to day noon." On April 9, 1827, he expounded in greater detail:

> *We this morning…have been playing ball, But I never have received so much pleasure from it here as I have in Bridgewater* [Massachusetts]. *They do not have more than 6 or 7 on a side, so that a great deal of time is spent in running after the ball, Neither do they throw so fair ball, They are afraid the fellow in the middle will hit it with his bat-stick.*

The first published information referencing baseball in Rhode Island is also connected with Brown University. The June 29, 1863 edition of the *Providence Journal* records Brown's first intercollegiate game, in which Brown

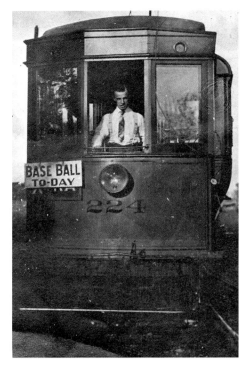

"Baseball Today" trolley, circa 1908. *Author's collection.*

hosted Harvard at the Dexter Training Grounds in Providence. This article records, in great detail and with much fanfare, the game, as well as festivities centered around the game. Of historic interest is the fact that the opening ceremonies included a performance by America's oldest brass band, Rhode Island's own American Band, which was incorporated in 1839 and still performs today.

There are many documented references from 1863 to 1870 noted in Rhode Island newspapers regarding a well-developed system of baseball competition beginning in the late 1850s. Several articles found after 1866 refer to baseball championships being held in Providence from 1858 to 1862. By the end of the 1860s, Woonsocket, Warren, Warwick, Bristol, Pascoag, Providence, Cranston, Pawtucket and many other Rhode Island communities had developed town teams, many of which were semiprofessional.

# 1870–1890

## *A Time of Growth and Development of Professional Ball*

The 1870s were a time of unprecedented growth in the popularity of baseball in Rhode Island. It is doubtful that any decade has surpassed it since. From 1870 to 1880, over 120 baseball teams had organized in the Ocean State. These teams included one Major League team and professional, semiprofessional, amateur, college and high school teams. Some teams had odd names, such as the Infants, Actives, Silver Heels, Lightfeets and Wide Awakes. Other teams were much more serious in their baseball endeavors. Three of these more serious teams deserve special note in this section. They

# Historical Notes

are the Providence Juniors, the Rhode Islands and, of course, the National League Providence Grays.

## *The Providence Juniors*

Four significant teams developed simultaneously in the early 1870s: the Auburns and Athletics of Cranston, the Bristols and the Providence Juniors. All were semiprofessional teams signing players to contracts and sharing gate receipts. The Auburns and the Bristols were known as very competitive teams. The Athletics, who played on the Cranston Print Works grounds, were best known for their fighting ability. In these early games, fights often occurred before a game could be completed. One of the main reasons for the fights was due to the fact that betting was heavy at all games. In fact, violent outbreaks were not uncommon. In 1926, Providence sportswriter William Perrin penned a series of articles describing the beginning of baseball in Rhode Island. The following account is an example of just one such game in which the Juniors were involved in 1872.

> *To prove that scandals are not the exclusive property of modern baseball, an incident concerning these two teams (Providence Juniors & the Bristols) stands out prominently. In one game of a series, large sums of money were wagered, the Bristol boys going into the battleground loaded with money which was freely bet and covered as fast as shown. The Providence Juniors won the game, but the captain of the Bristol team nearly lost his life. He played wretchedly and his slips cost Bristol the game. He was accused of having sold the game and was chased by his irate fellow townsmen on murder bent. He escaped, but never appeared in Bristol again, so it is said.*

As significant as the Cranston and Bristol teams were, the Providence Juniors is the team that set the table for the development of professional baseball in Rhode Island. The Juniors not only were excellent ballplayers, but they also played with style and were well organized. They played a set schedule, held exhibition games with touring professional teams, wore uniforms and signed the best local players to contracts. As a direct result of a financially successful year for the Juniors in 1874, the well-respected and local baseball enthusiast General Charles R. Dennis put together a number of Providence investors and developed the Rhode Islands for the 1875 season.

# Rhode Island Baseball

## *The Rhode Islands*

To help make the Rhode Islands a financially successful enterprise, a brand-new, state-of-the-art enclosed ball field (Rhode Island's first) was constructed between Broad and Elmwood Streets on Adelaide Avenue. Adelaide Park seated fifteen hundred persons, was sizable for its time at five hundred square feet, contained a grandstand, offered ice cream at a brand-new soda parlor and even came complete with a large oak tree with bleachers built around it, offering shade on hot days. Enclosed (fenced-in) ballparks were the key to the financial success of professional baseball teams, for without an enclosed park, collecting admission from patrons was very difficult.

The Rhode Islands featured ten ballplayers (listed below) in their three-year existence who gained some baseball notoriety nationally by playing in the Major Leagues.

*Thomas Healy* (Rhode Islander), pitcher for the National League Providence Grays and National League Indianapolis Blues
*Jeremiah Turbidy*, Union Association, Kansas City Unions
*Thomas Everett Burns*, thirteen Major League seasons
*Steven Brady*, six Major League seasons
*Ned Hanlon*, famous early ballplayer and Major League manager
*William Tobin*, 1888 Worcester Brown Stockings and Troy Trojans
*Fred Corey* (Rhode Islander), pitcher for the National League Providence Grays
*John Daily*, 1875 National League Washington and Philadelphia Athletics
*"One Arm" Daily*, feared pitcher of several National League seasons; lost one hand as a child in an accident
*Frank Sellman* (Selman), five Major League seasons

Although successful in signing great players and often drawing good crowds, the Rhode Islands had a turbulent three-year existence. The pay for players was low in comparison with the Major League salaries of the time, and owners and players often did not get along. The Rhode Islands was perhaps the first professional team to have players unite around pay issues. After the 1876 season, the owners and the players, represented by Manager Willis Arnold, met to work out details for the 1877 season. Although the Rhode Islands was a professional team, local promoters were not driven by profit and felt their players should not be driven solely by profit motives either. The players demanded higher salaries, which the owners could not provide. When the players did not get what they wanted, Manger Willis moved the whole team, with the exception of outfielder Matt Barry, to Auburn, New

# Historical Notes

York, ending the Rhode Islands' existence as such. Rhode Island was left with a legacy that set a high expectation for all future professional teams. In the three years of the team's existence, the Rhode Islands won ninety-five games and lost fifty-nine, for a .621 winning percentage. No other professional team in the Ocean State has been so successful.

## *The National League Providence Grays*

The original articles of incorporation for the Providence Grays may be found at the Rhode Island State House Library in *Acts and Resolves, Passed by the General Assembly of the State of Rhode Island and Providence Plantations, at the May Session, 1878, and the Adjournment Thereof in June, 1878.* (Now that's some title! Basically, the book is an account of the general laws of Rhode Island passed in 1878. Unlike modern businesses, which incorporate through the secretary of state, many businesses like the Grays from the 1800s were incorporated by an act of the state legislature.)

The Providence Grays began play in May 1878 and was eventually bought out by the Boston Beaneaters (Boston Red Stockings) in 1885; however, not before the team established itself in baseball history. Providence played home games at Messer Street Grounds (near Union Street). The Grays played such teams as the Boston Beaneaters (Boston Braves), the Red Stockings Ball Club of Cincinnati (Cincinnati Reds) and the New York Metropolitans

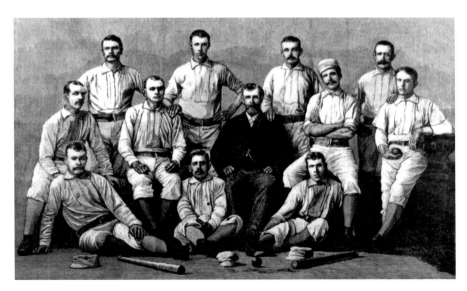

The 1882 National League Providence Grays. Harper's Weekly, *September 30, 1882. Author's collection.*

(later to be reincarnated as the New York Mets that won the 1969 and 1986 World Series). The Providence Grays won its first pennant in 1879 in what was reported in newspapers in every baseball city as having been the most exciting pennant race to date.

Most people believe that the first World Series was played in 1901. However, this is not true. The first World Series was held in 1884 between the National League and the American Association. The Providence Grays represented the National League and the New York Metropolitans represented the American Association. The Grays won the 3-game World Series three to zero behind the pitching of Hoss Radbourn. That year, the league had just passed a rule allowing pitches to be thrown overhand. Radbourn may have been the greatest overhand pitcher in the history of baseball. That season, the Grays played a schedule of 112 games. Old Hoss Radbourn pitched 73 of the games and won 63, including 3 in the World Series. The unbelievable success of Radbourn was the eventual downfall of the Grays.

During the eight years of its existence, the Grays contributed a number of "firsts" in the game, including being the first team

- to abandon white uniforms (and wear gray uniforms, hence the name).
- to install turnstiles at the ticket gates.
- to put up wire mesh behind home plate to protect spectators.
- to develop the concept of a "bullpen," originally built for horses and carriages and later used for pitchers.
- to have an outfielder, Paul Hines (1878), complete an unassisted triple play. (Hines was also the first baseball player to wear sunglasses on the field.)
- to boast the most lopsided victory in baseball history: a twenty-eight to zero drubbing of the Phillies on August 21, 1883.
- to win a World Series.

With its rich history and many innovations, you might think that the Providence Grays would be immortalized in the Cooperstown Hall of Fame. However, if you comb your way through the museum, you will only find the Grays mentioned in a few inconspicuous places. The team is not mentioned at all in the large Baseball Time Line Exhibit. Despite this, the Providence Grays enjoy an immortal status among Rhode Islanders and the national game.

# Historical Notes

## COMMENTARY AND HISTORIC FOOTNOTES

### *Black Ball in Rhode Island*

Unfortunately, a viable written record for how black men and women in Rhode Island played the game is extremely limited. There is no doubt that baseball was an important part of black history in the Ocean State, but due to institutional discrimination, the story remains largely undocumented and certainly untold. The earliest recorded date found at the time of this printing for black baseball played in Rhode Island is August 17, 1877, when a game between the Rhode Islands and the Mutuals took place. The Mutuals were a traveling black team from Washington, D.C. The game was won by the Rhode Islands six to zero. The first black Rhode Island team that has been found to date was the Providence Colored Grays, and it played the Pascoags on September 9, 1886. The team was shorthanded and lost to an excellent semiprofessional Pascoag team thirteen to three. This game was umpired by a black gentleman named Mr. Howard. Howard may have been the first black Rhode Island umpire to ump a game with white players in the state.

Perhaps the longest running black team was the Providence Giants, which began playing sometime prior to 1902 and existed until at least 1932. A grand ballplayer, Daniel Whitehead ran the team at least from 1902 to 1930. The last owner of a Providence Colored Giants team was Arthur "Daddy" Black, who was murdered on the evening of September 24, 1932, by five black men from New York City. Black was shot down in his own home in a blaze of gunfire. Besides being the owner of the Providence Colored Giants, he was a numbers runner and illegal lottery promoter.

Many traveling black teams, like the Washington Mutuals, traversed Rhode Island, taking on any teams willing to host them. The famous Cuban Giants made Rhode Island a regular stop, and in later years teams like the Pullman Porters,

Daniel Whitehead, manager of the Providence Colored Giants, 1910. *Source unknown.*

Black Yankees and New England Black Giants also frequented ballparks throughout the state.

Most historians believe that Fleetwood Walker was the first black man to play in the Major Leagues. However, recent research indicates that Brown University student William Edward White—the son of a black slave, Hannah White, and a white plantation owner, Andrew J. White—played one game with the National League Providence Grays in 1879.

The honor of the most distinguished Rhode Island black ballplayer has to go to one William A. Heathman Esq. Heathman attended Brown University from 1891 to 1892 and played on the Varsity Ball Club. He transferred to Boston University, where he obtained a law degree. Moving back to Rhode Island after graduation, he became the first black man to be admitted to the Rhode Island Bar Association. He was the first black person to be appointed to the U.S. Circuit Court (1901) and the first black person to serve as a clerk for the Rhode Island Supreme Court. Heathman lived to be over a hundred years old and practiced law until his death.

## Disability and Baseball

Throughout the history of baseball, men and women with disabilities have played the game at all levels. From reading contemporary press reports of great players like "One Arm" Daily or "Three Finger" Brown, one can deduce that having an "infirmity" during the late 1800s and early 1900s was viewed a little differently than it is today. On one side of the coin, individuals with a disability were thought to be inferior or less fortunate; on the other side of that same coin, individuals who succeeded in their profession were treated no different than if they did not have a disability. In the early years of baseball, alcoholism and physical and mental disabilities were not uncommon among ballplayers. As long as they performed, nobody made it their business. This is perhaps best illustrated by comments from Tommy Leach, a teammate of the Major League's first deaf ballplayer, William Ellsworth "Dummy" Hoy.

> *I roomed with Dummy in 1899, and we got to be good friends. He was a real fine ballplayer. When you played with him in the outfield, the thing was that you never called for a ball. You listened for him, and if he made this little squeaky sound, that meant he was going to take it. We hardly ever had to use our fingers to talk, though most of the fellows did learn the sign language, so that when we got confused or something we could straighten it out with our hands.*

# Historical Notes

A Brown University pitcher, circa 1895. Despite an infliction caused by polio, this student was able to realize his ambition and play for Brown University's varsity team. *Courtesy Brown University John Hay Library.*

Hoy's disability was responsible for umpires using hand signals to call balls and strikes. Umpires who called games in which Hoy played developed the signals that later caught on, so that all players and the fans could keep track of the count. This was not the first time, nor would it be the last, that invention related to diversity benefited us all.

# PART II

# THE PLAYERS

> I am all out for the stuff.
> —Nap Lajoie's response when offered his first professional contract with the Class B Fall Rivers

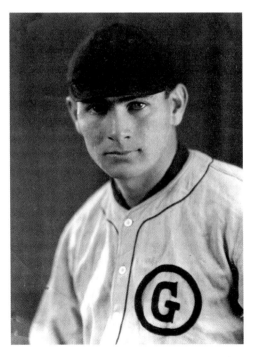

Unknown player. A striking and haunting individual. *Author's collection*.

CHAPTER 7

# JOSEPH START

### *"Old Reliable"*

*Born: October 14, 1842, in New York City, NY*
*Died: March 27, 1927, in Providence, RI*
*Height: 5' 9"*
*Weight: 165 lbs.*
*Major League debut: May 18, 1871*
*Final game: July 9, 1886*
*Batted: left*
*Threw: left*

Born in New York City on October 14, 1842, Joseph Start moved to Rhode Island in 1879 to play for the Providence Grays. Start remained a Rhode Islander until his death in 1927. In the "barehanded" era of baseball, the two most important fielding positions were catcher and first base. Start earned his nickname "Old Reliable" by playing consistent and quality defense at first base.

Joseph Start, 1882 National League Providence Grays. Harper's Weekly, *September 30, 1882. Author's collection.*

What has impressed me about Start to a great extent is his stately appearance. No matter which image is viewed and from what part of his life, he appears as a most distinctive gentleman. Perhaps a more distinguished-looking ballplayer can not be found on Rhode Island's long list of gentlemen (and women) who have played the game. Both in his play and his life, he was a man to be respected. A popular local sports figure, "Old Joe Start" was often seen walking certain streets of Providence, tipping his derby to the ladies, and he was frequently observed discussing matters of some importance with an unknown passerby.

# Rhode Island Baseball

## The Early Years

### *The Enterprise, Atlantic, Mutual Base Ball and Hartfords Baseball Clubs*

According to local baseball historian and author Frederick Ivor-Campbell, Start began his baseball career playing at age eighteen for the Brooklyn amateur club, Enterprise, in 1860. The Enterprise Baseball Club was one of the very earliest clubs formed in America. In 1862, Start signed on with the Atlantics. The Atlantics were a very powerful team and were known as the team that ended the famed run of victories by the Cincinnati Red Stockings (1869–1870). After successfully playing for the Atlantics, Start signed his first professional contract with the New York Mutuals of the National Association in 1871.

The Mutuals originally formed in 1857 as the New York City Mutual Hook and Ladder Company No. 1 Baseball Club. In the 1860s, the team was known to throw a game or two during the season, especially when New York's mayor, Boss Tweed, was in the betting pool. Tweed, who developed the concept of "Big City Boss," maintained the so-called "amateur" squad (the Mutuals) by putting ballplayers on city payroll into jobs that didn't exist. Most of the jobs were in the coroner's office—an ironic twist to this dark practice. The Mutuals of the 1860s built a well-deserved reputation as gamblers, roughnecks and patrons of other illicit activity, all of which were covered liberally by the local press. Fortunately, by the time Start joined the team, these activities had calmed down somewhat, although they were still considered a somewhat "dirty team." There is no evidence that Start ever participated in any illegal activities, an act that would have been totally out of character for him. Unfortunately, the same could not be said for the team, which could not escape its reputation and went bankrupt in 1877 due to low attendance caused by the lack of public trust.

After the 1877 season and the fall of the Mutuals, Start signed with the Hartfords. Hartford had entered the National League as a founding member in 1876. The team, known officially as the Hartford Dark Blues, had moved to Brooklyn in 1877, and in that year Start hit .332 with the club. The Dark Blues' owner, Morgan Buleley, holds the distinction of being the first owner to ever break a promise not to move a team because of financial considerations. He made the promise to Hartford residents in 1876 and moved the team in '77. In professional sports, this practice by owners is now quite commonplace.

# Joseph Start

## START'S LEGACY CONTINUES TO BUILD

Joe Start's baseball life represents a tapestry of many important baseball events and the befriending of many of baseball's earliest and greatest players. He played in the game in which the Atlantics defeated the unbeaten Cincinnati Red Stockings in 1870. He was an early member of the oldest continuous baseball franchise, the Chicago Cubs, which was founded in 1876. He also played in the last game in which A.G. Spaulding participated. Spaulding retired from playing baseball and established the A.G. Spaulding Sporting Goods Company, lobbied the National League to install electric lights in 1883 so teams could play at night and was largely responsible for the Abner Doubleday myth. After one year with the Cubs, Start came to Rhode Island to play for the National League Providence Grays in 1879.

With the Grays, he played quality and consistent ball while continuing to weave his baseball tapestry. While playing with Providence, he batted over .300 three times and also participated in the first World Series. He played with both George and Henry Wright and with the great Hoss Radbourn.

The value of Start to the Providence Grays was well documented by the local press, which considered him to be the best fielding first baseman in the league. His value was also demonstrated in monetary terms. The entire payroll for the Grays in 1881 was $13,175. Start's salary of $1,600 was second only to that of pitcher Montgomery Ward, who topped the team at $1,700. In stark contrast, rookie and future great Hoss Radbourn was paid only $900.

There are only a few men who could boast a more all-encompassing experience in the very beginnings of baseball than Start. From the game's elementary roots in New York to the many innovations of the Providence Grays, Old Reliable was there. Start's longevity (twenty-six seasons) can be attributed to his great skills. He posted seven seasons of batting higher than .300, he led the league in fielding percentage for several seasons and he was experienced well beyond most players of his time. By all accounts, he was as morally solid off the field as he was on it, which was a rarity at the time. For many years after he retired from baseball, he operated a small inn near the corner of present-day Route 1A and Route 117 in the Lakewood Section of Warwick. He died at age eighty-two, a "grand old man" of baseball, who was witness to the very early development of the modern game.

## *The Lakewood Inn*

Start's Inn was at a very good location and was located near where the gas station on the corner of present-day 1A and Warwick Avenue now stands.

Location of Joe Start's inn at Lakewood, Rhode Island. Sanborn Map Company. Published 1922.

During the time Start owned the inn, he would have received vehicle patrons from the well-traveled Warwick Road (now Warwick Avenue) and the electric railroad (trolley) along past and present Brook Avenue. Short Street is no longer in existence.

One last piece of baseball information on Gentleman Joe: during his last year in professional baseball, Joe was a teammate to a scrappy young upstart catcher. The rookie's name? The "Gentleman" of all baseball gentlemen, Connie Mack.

## Chapter 8

# Hugh Duffy

### *"Sweet Old Guy"*

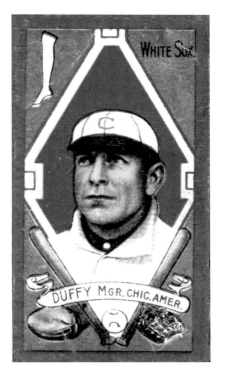

Hugh Duffy. Series T–205 Tobacco Card, 1910. *Author's collection.*

*Born: November 26, 1866, in Cranston, RI*
*Died: October 19, 1954, in Boston, MA*
*Height: 5' 7"*
*Weight: 168 lbs.*
*Major League debut: June 23, 1888*
*Final game: April 13, 1906*
*Batted: right*
*Threw: right*

Hall of Fame inductee Hugh Duffy was known as the "Sweet Old Guy" in his later years. His swing matched his disposition, but "sweet" doesn't describe the man in his competitive years. Duffy collected so many accolades in his seven decades in baseball (1884–1954) that they can't all be included in this chapter. He holds the Major League record with the highest batting average at .440 (1894), a mark that has stood for over 106 years. He was baseball's first $5,000 a year man. Duffy was an outstanding defensive outfielder and a terror on the base pads, with 584 Major League steals. In short—and he *was* short at five feet, seven inches—he was a "five-tool" player. He played great defense, had speed, scored and knocked in runs and hit for average and power.

Hugh Duffy was always a gentleman, but to opposing players, "sweet" he certainly wasn't. Duffy was known to utilize the popular practice of sharpening spikes before a game to dissuade fielders from hugging the bases too close to the bag during attempted steals. He also once challenged a six-foot-three catcher for the Pittsburgh Pirates when he tried to "tip his bat" as he was swinging. Duffy turned around to the big fellow and said, "You tip my bat once more and I'll break it over your head, you big shadpoke!" The big "shadpoke" was future Hall of Fame inductee Connie Mack. (For those readers with an inquiring mind, a "shadpoke" is an archaic term for a herring bag.)

## The Early Years

Born in River Point in 1866 and raised in Cranston, not much evidence exists of Duffy's early experiences in baseball. He played on several mill teams and played well enough to be signed by Hartford of the Eastern League at age twenty. In his inaugural professional year, he played in seven games and batted .278. In 1887, he displayed his true offensive abilities while splitting time between Springfield (Eastern League) and Salem-Lowell (New England League). At Salem-Lowell, he had 325 at-bats and hit for a lofty .438 average. He wasn't long for the minor leagues, however—the following year he would be playing in Chicago.

## Duffy's First Team

"Where's the rest of you," yelled Cap Anson as Duffy took the field for his first Major League game. "This is it!" fired back Duffy. In the two years that Duffy played with the Cubs, future Hall of Famer Anson and Duffy never spoke again, reportedly due to Duffy's rough introduction. While playing with Chicago, he hit .282 and .312 respectfully. In 1890, he jumped leagues along with many other stars and signed with the Chicago Pirates of the Players League, where he hit .328. The following year he joined the Boston Reds of the American Association.

# Hugh Duffy

## A Decade in Boston (And What a Decade It Was!)

Very few ballplayers have ever had a decade that can match Hugh Duffy's ten years of ball playing at the end of the nineteenth century. He hit over .300 for eight seasons, led the league in average twice while setting the Major League record in 1894, led or tied for the lead in the league twice in runs scored, had over 200 hits twice and led the league in hits, doubles, home runs and fielding percentage once. In his prime ten years, he also stole 584 bases and scored 1,283 runs. From 1891 through the 1900 season, he played with the Boston Beaneaters. The year 1894 was one that dreams are made of for Hugh Duffy. Besides setting the record for average, he led the league in hits, with 236; doubles, with 50; and tied for the lead in home runs, with 18. Throughout the decade, his defense was outstanding. Even though Anson and Duffy were not on speaking terms, Anson said of him, "Hugh Duffy of Boston plays the outfield carrying a crystal ball. He's always there, waiting to make the catch."

## The Player/Manager

A common practice in the early years of professional baseball was to use a player in his twilight years as a manager. Payrolls were a bit thin in the early era of the game, and this was one way for owners to save money while utilizing the expertise of an experienced veteran. Younger readers today may not be familiar with the player/manager role—Pete Rose was the last one at the Major League level. All three Rhode Island Hall of Fame inductees were player/managers: Nap Lajoie, Gabby Hartnett and Hugh Duffy.

Duffy began his managing career when he signed on with the Milwaukee Brewers of the newly formed American League in 1901. (This version of the Brewers is not related to the current Milwaukee Brewers. In fact, the 1901 Brewers played only one season before owner Henry Killilea bought into the Boston Pilgrims [Red Sox] and let his franchise be sold to St. Louis.) The Brewers had been a minor league team in 1900 managed by Connie Mack. When Duffy was hired to manage the new Major League team, he immediately became on the outs with owner Killilea. He claimed that Killilea did not spend enough to entice National League players to jump leagues. Killilea simply replied that he didn't have enough money. A lack of funds was evident in the starting lineup, where Duffy had the second highest batting average on the team with .308. The Brewers did manage to

complete the season, finishing in last place in the American League, going forty-eight and eighty-nine.

Duffy remained in Milwaukee for two years as a player/manager for the Class A Milwaukee Creams of the Western League. The 1902 team finished one game out of first place with a .597 winning percentage. Duffy contributed with 505 at-bats, hitting at a .291 clip. The 1903 version of the Creams fared even better by winning the Western League pennant, with a .659 winning percentage. Duffy took the helm of the Philadelphia Phillies in 1904 and remained at the helm through the 1906 season. Duffy's tenure in Philadelphia wasn't a memorable one. In his first year, his team finished in the cellar with one hundred losses although Duffy hit .300 in seventy-one games. The following two seasons, the Phillies had winning seasons, finishing fourth both years.

Duffy returned to his Rhode Island roots in 1907. He purchased the Class A Providence Grays (Clamdiggers) of the Eastern League. With the Grays, he was the owner, the manager and also played sparingly. In his three years as owner, the team had winning seasons, the best of which (1908) they finished second to the Baltimore Orioles. Ironically, the Orioles were managed by Jack Dunn, the Grays manager before Duffy came to town. Duffy's playing career ended after the 1908 season.

## 1910–1954

During the next fifty-four years, Hugh Duffy would coach, manage, own and scout ball clubs. A career that started at age twenty would not end until his death at age eighty-seven. During his time on earth, Duffy would meet thousands of ballplayers, see them develop and see them pass on. He played and worked with dozens of future Hall of Fame inductees. He was Ted Williams's first Major League coach. He played on countless ball fields and saw the building of the great ballparks, including Fenway, and the destruction of others. All told, Duffy played in 2,107 professional games and managed 2,668. He ended his career with a .330 Major League batting average and 2,307 hits. All of this from a "Sweet Old Guy" who was considered too short to play the game. He attended every spring training for the Red Sox from 1924 through 1953. In an interview just before he passed away, Duffy was asked how he maintained such good health at such an old age. He replied, "Exercise." His exercise? Taking twenty swings of the bat every morning. People who saw him take those swings say he never lost that "sweet swing," not even near the end.

# Hugh Duffy

## Summary

1886–1908: ballplayer
1901: manager, Milwaukee Brewers (American League)
1902–03: manager, Class A Milwaukee Creams (Western Association)
1904–06: manger, Philadelphia Phillies (National League)
1907–09: owner/manager, Class A Providence Grays "Clamdiggers" (Eastern League)
1910–11: manager, Chicago White Sox (American League)
1912: manager, Class AA Milwaukee Brewers (American Association)
1913–16: president/manger, Class B Portland Duffs (New England League)
1917–19: scout, Boston Braves (National League)
1920: manager, Class AA Toronto Maple Leafs (International League)
1921–22: manager, Boston Red Sox (American League)
1924–54: scout/coach, Boston Red Sox (American League)
1937: inducted into the Hall of Fame

CHAPTER 9

# CHARLES LEO HARTNETT

*"Gabby," "Dowdy," "Tomato Face"*

*Born: December 20, 1900, at Woonsocket, RI*
*Died: December 20, 1972, at Park Ridge, IL*
*Height: 6' 1"*
*Weight: 195 lbs.*
*Major League debut: April 12, 1922, with Chicago Cubs*
*Final game: September 24, 1941*
*Batted: right*
*Threw: right*

## A BASEBALL FAMILY

Hartnett grew up in a baseball family. All of his siblings played ball, and his father was in great demand by local mill teams. Although born in Woonsocket, Hartnett lived most of his time in Millville while maintaining close baseball ties to Woonsocket. His favorite sandlot battery mate was Woonsocket native Tim McNamara, who went on to play for the Braves and Giants. Hartnett's brother, Chick, played professional ball briefly for the ill-fated minor league club the Woonsocket Cabbies, in 1933.

The 1933 All Star Game, National League. *Printed with permission by Mary Brace.*

Hartnett couldn't have come along at a better time to learn the craft of baseball. In the early 1900s, every mill of significance sponsored a semiprofessional team, and each town had a well-developed system of amateur and semipro baseball. As a teenager, a boy of Hartnett's talents and

local baseball family fame could always find teams begging for his services. As an eight-year-old boy he would have seen Woonsocket legends Louis LePine and Henry Rondeau, both Major Leaguers, and future Hall of Fame inductee Nap Lajoie in action at the Clinton Oval. The whole economy of the area centered around mill life, and baseball-playing sons of mill men were the heroes of the day. Baseball was the "one and only pastime."

In eighth grade, Hartnett quit school and became fully employed by the U.S. Rubber Shop in Millville. He played on the shop's baseball team, as well as on other area teams. In 1918, he became a student at Dean Academy. (Dean has a rich baseball history that predates the turn of the century, and many well-known baseball players graced the fields of the academy.) It didn't go well for Hartnett at Dean, and academic endeavor certainly wasn't one of his strengths. He returned to mill life, playing for Millville and the U.S. Rubber Shop teams. He eventually ended up with American Steel and Wire Company in Worcester (1921). This suited Hartnett well—since he was on the payroll, the hours and pay were better and the shop excused his many absences. Although hired by the company to play baseball, he didn't actually get into a game because he was signed in early spring by the Worcester Boosters of the minor league Eastern League for the 1921 season. He had a fairly good offensive year at Worcester, hitting .264. However, it was his defensive skills and aggressive all-out style of play that eventually attracted Chicago Cubs' scout Jack Doyle.

According to baseball historian James Murphy's account of Hartnett's signing, Doyle's assessment of a ballplayer included studying their face. He decided that Hartnett had strong facial features. Doyle would later recount that he was proud of his role in signing Hartnett and signed him because "he had a strong puss."

"Gabby" got his nickname on the train heading for the Cubs spring training in North Carolina (1922). While other Cubs were talking it up, Hartnett remained silent throughout the trip. Because he was so quiet, a Chicago newsman decided to call him "Gabby" and the name stuck. Other than gaining a new name, Gabby's first year in the Majors was rather uneventful. He played in thirty-one games and hit .194 with no home runs. The following year, 1923, his playing time increased and he hit a respectable .268. Catchers throughout the first half of the century were not expected to be offensive powers as we have come to expect today. The position was thought of as a defensive position and most catchers hit for low averages. Hartnett's value was thought to lie in his accurate throwing arm and his ability behind the plate. That would soon change, however, as he became the most productive offensive catcher of his time.

# Charles Leo Hartnett

In 1924, Hartnett began to show his offensive prowess by hitting .299 and clubbing 16 home runs. The following year he hit 24 round-trippers. It is important to note that these home runs were hit at a time when, other than Babe Ruth, a player hitting 20 to 25 home runs was still considered a novelty. Hartnett went on to have a fabulous career. He was twice named to the Sporting News All-Star Major League team, and in 1935 he was bestowed the National League Most Valuable Player Award. He helped his team win four pennants while leading the league in fielding percentage for catchers a total of six years. Hartnett was also a six-time all-star. His best year was 1930, when he hit 37 home runs, batted .339 and knocked in 122 runs.

Hartnett became a player/manager for the Cubs in 1938 and stayed with the club until his unconditional release at the end of the 1940 season. His last season in the Majors (1941) was spent with the New York Giants, where he was a player/coach. Seeing limited action in 1941 (150 at-bats), he still managed to go out in style, hitting .300 and producing five home runs. Gabby continued his career, as many players do in their twilight years, by coaching/managing and playing in the minors. He continued managing through the 1944 season—one year with Indianapolis of the American Association and the last two with Jersey City of the International League. He was out of organized baseball for the next nineteen years, opening a recreational center that included a bowling alley and pool hall in Lincolnwood, a suburb of Chicago. In 1965, he joined the Kansas City Athletics staff as a scout and later worked in the Athletic Public Relations Department. Hartnett was inducted into the Hall of Fame in 1955.

## GABBY STORIES

Gabby's story could not be complete without mentioning his brushes with baseball fate and improbability. He was involved in several of the most famous baseball stories, managed to get himself into the *Guinness Book of World Records* and generally had a quirky aura around his life.

### *It Starts with Family*
Fred and Nell Hartnett had fourteen children and Gabby was the firstborn. The next six births by Mrs. Hartnett were all boys and the last seven births were all girls.

## Two Woonsocket Greats

The authoritative baseball encyclopedia *Total Baseball* lists the top one hundred baseball players of all time. There are two players born in Woonsocket on this list: Nap Lajoie and Gabby Hartnett. There have been millions of young men and women who have played baseball in America, tens of thousands who have played semiprofessional or professional ball and only just over fifteen thousand who have played in the Major Leagues. Around the turn of the century, Woonsocket was a city of about twenty-eight thousand. No respectable Las Vegas bookie would try to "make odds" on two players of this caliber coming from the same small mill city, but it happened—and one of them was Gabby.

## First Major League Game

Despite growing up in a family that ate, played and slept baseball and lived less than thirty miles from two Major League teams, the first Major League game Gabby saw was his Major League debut for the Cubs.

## The Strange Case of the Dead Arm

Gabby Hartnett was an all-around player. He hit for average and power, he played superior defense and he had an extremely high level of "baseball smarts"; however, his most feared attribute was the bullet he had for an arm. Very few base runners ever tried to steal on Gabby, and those who did had a slow walk back to the dugout. Hartnett was also one of the most durable catchers to ever have played the game, setting a National League record of catching one hundred or more games per season for twelve years. However, that was not the case in 1929, when he played in only twenty-five games.

At the beginning of the 1929 season, Gabby came down with a "dead" arm. The problem was investigated by medical personnel, but no medical reason could be found. Gabby certainly didn't have a clue either. Then he spoke to his mother, and when he told her about his arm, she asked a strange question, "Is your Martha [Gabby's wife] pregnant?" As it turned out, she was. According to his mother, the arm woes were the result of his wife's pregnancy. Gabby's mother went on to claim that his "arm will be better as soon as the baby is born." Later, Gabby stated, "And that's exactly what happened." Gabby's first child was born on December 20, 1929. Gabby's arm immediately felt better and he never had another problem with it.

## Ruth's Called Shot

*October 1, 1932. New York Yankees versus Chicago Cubs. Third game of the World Series. Top of the fifth. Charlie Root pitching for the Cubs. Ruth up to bat.* Remember

the famed home run hit by Ruth, "the called shot"? According to the annals of baseball lore, Ruth supposedly pointed to the center field bleachers and then, on the next pitch, deposited the ball right where he had pointed. The man behind the plate? Who else but Gabby Hartnett. The event did take place, but was it a "called shot" or was there another explanation?

Hartnett was the closest to the action and later recounted the event in this fashion:

> *Our bench jockeys were yelling at Ruth. At each of the two called strikes, Babe held up his hand, pointed his finger, and yelled to our dugout, "It only takes one." He did not point to where he hit the home run on Root's fifth pitch.*

For those of you who must know the truth, Ruth himself, in an October 2, 1932 *Chicago Tribune* article, declared, "Hell no, only a damn fool would do a thing like that," referring to his supposed "called shot." Ruth went on to confirm Hartnett's version of the story. Why does the false version of the story continue to be told to this day? Well, we all know that "the Babe" was bigger than life itself—even his own.

## *Second Annual All-Star Game*
Polo Grounds, New York, July 10, 1934

Of all the all-star games, this one may contain the most famous story. One of the best pitchers of all time started the game for the National League. He was thirty-one-year-old Carl Hubbell. During this game, he accomplished one of baseball's greatest feats ever, one that has been retold countless times and featured in several baseball films. In the first inning of the game, Hubbell gave up a single to Charlie Gehringer and walked Heinnie Manush. What happened next could not have been predicted and was considered the greatest achievement in sports from the 1930s. Hubbell struck out the next five hitters—the most feared hitters in all of baseball. Babe Ruth went down, then Lou Gehrig, followed by Al Simmons and Jimmy Foxx. Finally, Hubbell struck out Joe Cronin. You don't need to be told who Hubbell's battery mate was, right? You guessed it—Gabby Hartnett.

## *Guinness Book of World Records Holder*
Gabby Hartnett holds the world record for catching a baseball from the greatest height. On April 1, 1930, at the old Seals stadium in Los Angeles, he caught two balls dropped eight hundred feet from a blimp. The feat has never been tried again. Of course, if a modern-day catcher were to try

this stunt, he would first have to get a waiver from his Major League team, obtain additional insurance and sign a contract for it to be filmed by a major network.

## *Gabby's First Major League Homer*
### NOT ONE, BUT TWO

Even Gabby's first homer was a little out of the ordinary in that he hit two in the game, one in the eighth inning and the game winner in the ninth. He would not have had the opportunity for his second home run if his club had not scored seven times to tie up the game after he hit his first. As a matter of historical significance, his second home run over the right field fence at Wrigley was one of the longest ever hit in the park.

## *The Homer in the Gloaming*

Gabby was involved in another famous baseball story. Unless you are at least sixty years old, you may never have heard of it. In the 1930s, '40s and '50s it was as well-known as Carlton Fisk's home run in the sixth game of the 1975 World Series.

On September 28, 1938, Pittsburgh was playing the Cubs at Wrigley. The Cubs were in the middle of a fight for the pennant, trailing Pittsburgh by half a game. Needless to say, this late in the season the game was a "must-win situation." We pick up the story in the bottom of the ninth, Cubs batting and the score knotted at five to five. At 4:30 p.m., Umpire George Barr informed Pirates Manager "Pie" Traynor and Cub's Player/Manager Gabby Hartnett that it was getting dark and the current inning would be the last. Cubs player Phil Cabarretta flew deep to center for the first out. Outfielder Carl Reynolds grounded out to first base for the second out. Next up was Gabby Hartnett. It was now 4:35 p.m., there were two outs and if Gabby made the third out, the game would end in a tie and be postponed. Gabby stepped to the plate as the sky grew darker. Hartnett swung at the first pitch and missed. Iowa-born pitcher Mace Brown threw again and Hartnett fouled the pitch. It was now one strike away from the end of the game. Brown pitched again and a loud clap, like thunder, filled the air. The ball sailed out toward the left field bleachers. The crowd and many players couldn't see it because of darkness. The umpire signaled "home run," even though no one could actually see where the ball landed. Game over. The spectators went berserk and Hartnett circled the bases under police protection. The Cubs went on to win the pennant, but lost the World Series to the Yankees in four games.

1. Commercialism and humor were both important ingredients in the evolution of the national pastime. Pictured is an 1888 trade card that is representative of both of these influences. Hall of Famer Cap Anson's Chicago Cubs lost out to the New York Giants for the 1888 National League pennant. Taking full advantage of this, the John A. Tolman Company of New York City printed up a trade card entitled "Baby Anson." No doubt the humorous card helped boost coffee sales the following year in the New York area. *Author's collection.*

2. George and Allen Carlson, Bank Street, Pawtuxet, circa 1912. Ken Carlson, George's grandson, stated, "I believe they played baseball before they learned to speak English." *Courtesy Ken Carlson.*

3. There is no doubt what this young man has in his future—baseball and studying, circa 1890. *Author's collection*.

4. Bob's Lunch, a "Motley Crew," circa 1939. *Courtesy Bob Bentley.*

5. The Burlington, Vermont U.S. Army team, 1909. *Author's collection.*

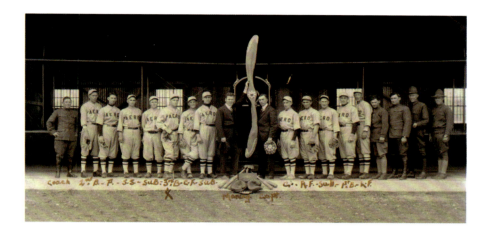

6. The U.S. Air Service baseball team, France, 1917. *Author's collection.*

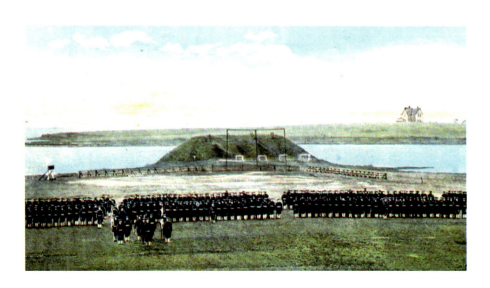

7. The Newport U.S. Navy Submarine Base, 1917. A practice baseball field can be seen in the background in front of the target berm. *Author's collection.*

8. Woonsocket's Gabby Hartnett graces the cover of *Baseball Magazine*. *Author's collection*.

9. *Left*: Joe Connolly, Rhode Island Major Leaguer. He won the Cracker Jack Prize in 1915. *Author's collection*.

10. *Bottom left:* Frank J. Corridon, Major Leaguer (1904–10) and a Newport native. He attended Rogers High School and played for the minor league Newport Colts. He was the alleged inventor of the spitball. Image circa 1910. *T-206 Tobacco Card. Author's collection*.

11. *Bottom right:* Jack Flynn, Rhode Island native and a Major Leaguer, circa 1910. *T-206 Tobacco Card. Author's collection*.

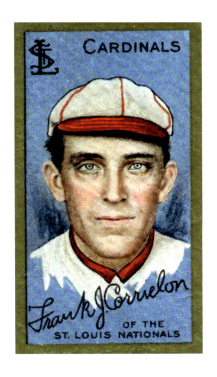

12. *Left:* Hobe Ferris, Rhode Island native and a Major Leaguer, circa 1910. *T-206 Tobacco Card. Author's collection.*

13. *Bottom:* Donkey baseball was popular in my small hometown of Elkhart, Iowa. Players, after getting a hit, would have to climb on a donkey to "run" the bases, while fielders, also on donkeys, struggled to get to the ball. To say it was a little chaotic and fun to watch would be an understatement. Photograph circa 1920. *Author's collection.*

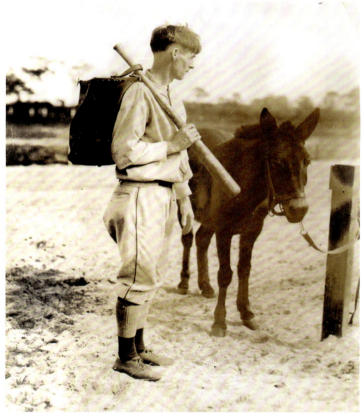

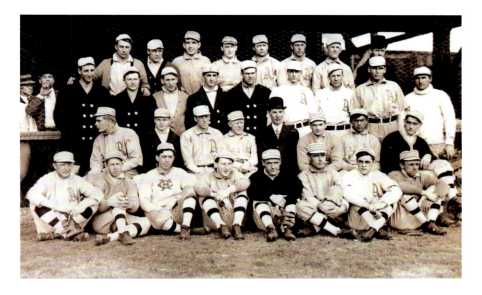

14. The 1908 Philadelphia Athletics at spring training. This team sported five Hall of Fame greats, including "Chief" Bender, Eddie Plank, Connie Mack (manager), "Home Run" Baker and Eddie Collins. Rhode Islander Augustus "Gus" Salve is at the far right in the second row. "Shoeless" Joe Jackson is also in the photo. 1908. *Courtesy Mrs. Raymond O. Anderson.*

15. Silent film star Edith Day taking a swing, 1925. *Author's collection.*

16. Liz Murphy, 1912. *Author's collection*.

17. A baseball game on the Dexter Street training grounds, 1915. *Author's collection.*

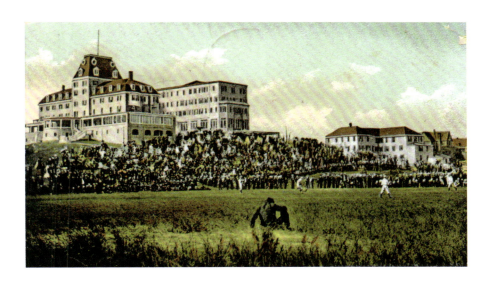

18. A baseball game on the Ocean House baseball grounds, Watch Hill, Rhode Island, circa 1897. *Author's collection.*

19. The Rocky Point baseball grounds, 1914. *Author's collection*.

20. A Tulsa Oil Company truck, with a player seated on the fender, circa 1925. *Author's collection*.

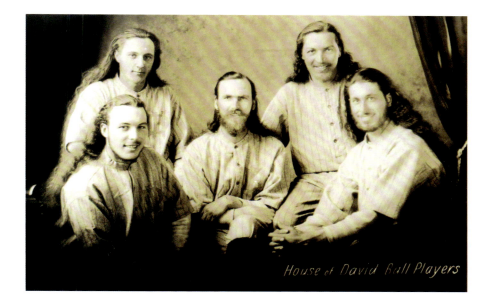

21. The House of David baseball players. The House of David team was part of a religious sect that did not believe in cutting hair. The team often barnstormed in Rhode Island, playing many local teams on each trip through. Photograph circa 1925. *Author's collection.*

22. A humorous postcard, circa 1905. *Author's collection.*

23. Another humorous postcard, circa 1905. *Author's collection.*

24. The umpire takes a beating. This practice was quite common prior to 1900 in semiprofessional and amateur games due to the level of betting on games. Image circa 1905. *Author's collection.*

25. The Pixies Baseball Club, circa 1905. *Author's collection*.

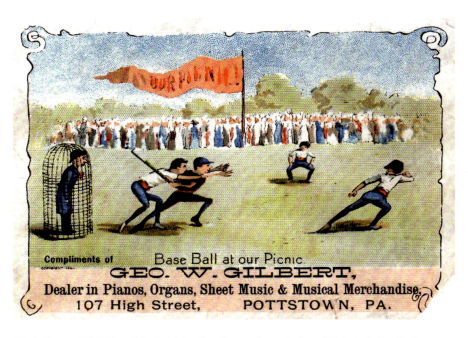

26. A George W. Gilbert Musical Merchandise trade card, circa 1895. *Author's collection*.

# Charles Leo Hartnett

## *He Died on His Birthday*

Perhaps, in other lesser-known aspects of Gabby Hartnett's life, fate may have been less involved. However, like his birth, Gabby again "beat the odds" on his death. One can die on any given day of the 365-day calendar year. The odds of dying on a particular day are 365 to 1. Gabby defied the odds one last time by dying on his birthday. He was born on December 20, 1900, and he died on December 20, 1972.

## NEVER TO BE FORGOTTEN

Charles "Gabby" Hartnett left a baseball legacy behind that few catchers can claim. Older residents of Millville and Woonsocket still swell with pride when his name is mentioned. An excellent tribute to Gabby may be found in the old Millville Public Library. And one more thing—as you drive from Rhode Island to visit the library and enter Millville on old Route 122, you will find that you are traveling on the Charles L. Gabby Hartnett Memorial Highway.

Chapter 10

# Napoleon "Larry" "Nap" Lajoie

### Loved by Woonsocket, Idolized by Cleveland

*Born: September 5, 1874, in Woonsocket, RI*
*Died: August 15, 1959, at Daytona Beach, FL*
*Height: 6' 1"*
*Weight: 195 lbs.*
*Major League debut: August 12, 1896*
*Final game: August 24, 1916*
*Threw: right*
*Batted: right*

Nap Lajoie, circa 1908. *Author's collection.*

Perhaps no ballplayer has ever been loved more by two cities than the "Big Frenchman" Nap Lajoie. In Woonsocket he was known as King Lajoie, and in Cleveland they named a Major League team after him—the Naps. Lajoie, generous to a fault, was loved by all, friend and foe. He lived a charmed life. He was a competitor, devoted family man, community leader and frugal businessperson. His baseball skills were unequaled during his time, and his knowledge of the game was unparalleled. He was the American League's first superstar—a true "five-tooled player."

By all accounts, he liked the idea of making money to play ball. It is not that he was greedy—as stated earlier, he was generous and was known to advance friends and family funds when needed—but he seemed to have a penchant for making owners pay for a commodity off of which they made money. As our story unfolds, this theme will become evident throughout his long baseball career.

# Rhode Island Baseball

Nap did not make much "stuff" as a mill sweeper in early industrial Woonsocket; however, he did make a name for himself playing first base and catcher on local semiprofessional teams. Lajoie once stated that he first became interested in baseball around the age of ten. This makes a lot of sense. Woonsocket had ball teams dating back to the early 1870s; however, the first great team, the Comets, developed in 1883 when Nap was nine. The Comets brought baseball to a feverish pitch in Woonsocket, a feat that could not have gone unnoticed by a scrappy little nine-year-old. In fact, the Comets were so good that a state-of-the-art ballpark was built for them and inaugurated in May 1883. Island Park seated fifteen hundred, a large number at the time, and was constructed with a covered grandstand, sold ice cream and lemonade and even had a section for "ladies." A sign of a good team in the early development of baseball was the ratio of home games to away games and the type of teams that were attracted. Many teams came to Woonsocket to challenge the Comets, who played twenty-five home games and only nine away games. They played National League teams, including the Boston Beaneaters, Philadelphia Phillies and Providence Grays. Many other notable teams visited as well. Despite the stiff competition, the Comets finished the season with a .874 winning percentage (twenty-eight to six).

During his early childhood, Lajoie played countless sandlot games and became known as "Sandy" for his light brown hair. (His boyhood friends would call him by that name for the rest of his life.) In 1891, when Lajoie was seventeen, the city once more would become enthralled with a good team, the Woonsockets, and Nap reportedly would go see them play as often as he could. The 1891 team was good; however, the 1892 team was great. The '92 version of the Woonsockets was a minor league team that boasted three past or future Major Leaguers, including Rhode Island's own Hi Ladd from Thornton (Cranston section). The Woonsockets were the first of several professional teams to call Woonsocket home. What a magnificent introduction to professional ball it was, with the Woonsockets taking the 1892 Class B New England League pennant. By 1893, the team returned to semiprofessional status; however, its namesake continued to play spottily over the next several years. In fact, the first team on which Lajoie made any money playing was on the 1894 Woonsockets, where he played catcher. In his first game, the Woonsockets played the Manvilles. Lajoie performed the catching duties, going one for four with twelve putouts. Lajoie played extremely well and stayed with the Woonsockets through the 1895 season, playing on the trotters track at old Agricultural Park.

# Napoleon "Larry" "Nap" Lajoie

## THE PROS

Lajoie began his twenty-two-year professional baseball career on April 30, 1896, playing for the Fall River Indians of the New England League. Nap played center field in his professional debut, batting one for four. In Lajoie's first professional season, he had a fantastic year, playing center field with the Indians and leading the league in batting average (.429) and putouts (280). He also contributed sixteen home runs in 380 at-bats, a hefty number during the dead ball era. His best minor league game was played on July 2, 1895 when he went six for seven, with a home run, two doubles and three singles. Lajoie was not long for the minor leagues. By mid-August, he would be playing for Philadelphia.

## BEGINNING HIS HALL OF FAME CAREER

Mirroring the circumstances of Lajoie's transition from semipro to pro is the controversy of how Lajoie came to be a member of the Phillies. The more common story has the Phillies hot for Fall River player Phil Grier. Indian's owner Charlie Marston allegedly offered Grier for $1,500. The Phillies balked, and Marston "threw in" Lajoie, a move that would make Nap the cheapest traded superstar ever. The late baseball historian James Murphy disputes this version, even though Lajoie often repeated it. Murphy wrote that he believed that the $1,500 asking price was for both Grier and Lajoie, not just for Grier. It is doubtful that the league's leading batter, Lajoie, who also displayed power, would be included in a deal for free. No matter how Lajoie got to Philadelphia, he began his long Major League career on August 12, 1896, playing first base. In that game, Lajoie had nine putouts and went one for five. For the remainder of the '96 season, he batted .328 and knocked in four more home runs. He had a great year in 1897, batting .363, setting a major league mark of eleven total bases in one game, and led the league with ten home runs.

In 1898, Lajoie moved to the position he would become famous playing—second base. In his years with the Phillies, he batted .328 twice, .363, .380 and .346 respectively. Playing second base, he matured as a Major League player, earning praise for his offensive as well as defensive prowess. In 1900, however, his employment with the Phillies was about to change. Always "out for the stuff," Nap saw opportunities arising with a new upstart rogue league headed by a fellow named Ban Johnson. At the turn of the century, a new and powerful league spearheading the "Century of Change" was about to

be born, and Nap was to be a key ingredient for its success. He became the most well-known star to jump to the newly formed American League.

According to Murphy's research, Lajoie was dissatisfied with the Phillies ownership's treatment of his contract. So at the end of the 1900 season, he made a secret deal with the part owner of the future American League Philadelphia Athletics, Connie Mack. Mack offered a contract for four years worth $24,000 through an intermediary, Frank Hough, a *Philadelphia Inquirer* sportswriter. Lajoie was unhappy with the maximum National League pay of $2,400 per year. (When all was said and done, Nap would actually make an additional $200 under the table with his new team.) With the creation of the American League, Lajoie severed his ties with the National League and jumped to the Athletics. He immediately added credibility to the new league, which was efficiently organized, well financed and robustly promoted under the competent leadership of Johnson. Lajoie became, in effect, the first major player in modern baseball history to successfully challenge the stronghold grip the owners had on players. He was the first free agent—albeit outlaw free agent—of significance.

Nap thrived in the new American League environment, leading the league in runs scored (145), hits (232), doubles (48), home runs (14), runs batted in (125), batting average (.422), slugging percentage (.643), on-base percentage (.463), putouts (403) and fielding percentage (.960). Those are huge numbers no matter what era or league. The crosstown jump was costly, however. Angered by Johnson's raiding of players under contract, the National League brass decided to make an example of Lajoie, and the National League Phillies owner Colonel John L. Rogers filed an injunction, trying to keep Nap from joining the Athletics. Besides using the legal system, the National League resorted to financial incentives to try and break Nap's contract with the Athletics and his loyalty to the infant American League. Giants owner John McGraw offered a three-year pact worth $21,000 to Lajoie, but Nap refused. McGraw then upped his offer to an unheard-of salary of $25,000 for two years. Lajoie remained loyal despite the incredible offer for the "stuff."

Meanwhile, a lower court ruled against the injunction, making Nap a bona fide Philadelphia Athletic—for a short time anyway. The lower court's ruling was overturned by the Pennsylvania Supreme Court, which upheld the National League's reserve clause. A court order forbade Lajoie playing for the Philadelphia Athletics. Nap missed several weeks before Connie Mack decided to give Lajoie to Cleveland of the American League. Cleveland would be Lajoie's home for the next twelve years. For the remainder of 1902, Nap could not accompany the team to play in Philadelphia due to the risk of

# Napoleon "Larry" "Nap" Lajoie

breaking the injunction and ending up in jail. The war between the American and National Leagues ended after the 1902 season, and Lajoie was free to play once more in Philadelphia and get on with his career. These distractions did not hurt him much, however—he ended up with a .366 batting average in 1902. (The reserve clause remained in effect until challenged by agent Marvin Miller and pitcher Andy Messersmith in 1975, clearing the path for today's sports millionaires.)

## Cleveland's Adopted Son, Injuries and a Few Great Men

In the early years of baseball, a great deal was made out of team nicknames, and team names changed often. For instance, the Boston Red Sox were also known as the Americans, Puritans, Pilgrims and Somersets. In many years, the minor league Providence Grays were known as the Clamdiggers. This tradition also held true for the current Cleveland Indians. The name "Indians" is in honor of little-known American Indian player Lou Sockalexis of the Penobscot tribe who played for Cleveland from 1897 to 1899. (Sockalexis died in 1913 from an alcohol abuse–related illness.)

Prior to their present name, the Indians were known as the Blues, Broncos, Molly McGuires and Naps. By the time Lajoie joined Cleveland in 1903, he was a bona fide superstar. Before he left the '03 spring training camp, readers of the *Cleveland Press* had already selected a new team name in a contest sponsored by the newspaper. The new name was the "Cleveland Naps" after Lajoie's first name, "Napoleon." For twelve years the team would carry Lajoie's name.

During Lajoie's twelve-year stay, Nap would lead the league thirty times in eleven different offensive and defensive statistical categories. Although his earlier years were great, the years with Cleveland were what made Lajoie a Hall of Fame inductee. He played with or against some of the greatest players of all time, including Cy Young, Tris Speaker, Honus Wagner and Ty Cobb. Lajoie was the captain of the team from day one and managed it between 1905 and 1909. After two subpar offensive years in '07 and '08, he relinquished his managership in 1909 to concentrate on his playing. It worked! In the years between 1909 and 1913, he batted .324, .384, .365, .368 and .335, respectively.

The biggest controversy surrounding Lajoie's playing career took place in 1910. At stake was the American League batting title and a brand-new Chalmer's automobile. (Keep in mind that this prize was very significant since very few Americans owned an automobile in 1910 and a Chalmer's

was considered to be one of the classiest cars around.) The race was between respected and loved Larry Lajoie and respected and despised Ty Cobb. Very few players were rooting for Cobb, as many had been victim to his high-spiking technique of sliding into bases. If a player was near a base when Cobb slid, he could expect a deep cut or even stitches. In the eyes of many fans and players, the completion was "good against evil."

Watching the race for the batting crown became a national pastime. As the season neared its end, arguments in bars and saloons across America were prolific. Adding fuel to the fire was confusion about the exact tabulation of the averages. At one point, Major League Baseball, local newspapers and national news/sports publications were all in disaccord in relation to the numbers. By early October, with just one game left, Cobb appeared to have had the title sewed up. However, this was not to be the case.

Cobb sat out the final two games of the season, thinking he had wrapped up the crown. Lajoie, playing a double-header on the last day of the season, tripled his first time up in the first game. What happened in the next eight at-bats would send the baseball world topsy-turvy and cause all hell to break loose around America. Third baseman Red Corriden of St. Louis played uncharacteristically far back of the line, later claiming that manger Jack O'Connor had instructed him to do so. Lajoie took advantage of this and bunted six times down the line for a base hit each time. On his seventh trip to the plate, he bunted and was credited with a sacrifice because he had moved over a runner. On his ninth and last at-bat of the double-header, he bunted once more. Shortstop Bobby Wallace fielded the ball but threw wildly to first. Lajoie was credited with a hit, making his tally for the day eight for eight, edging him ahead of Cobb by .3868 to .3834. When questioned about the placement of his third baseman, O'Connor simply stated, "Lajoie outguessed us." The press, although supportive of Lajoie, didn't buy it. Neither did American League President Ban Johnson. Within a few days, O'Connor and St. Louis coach Harry Howell were both out of work.

Cobb was awarded the title, hitting .385 to Lajoie's .384. These figures are still in the official record books. Much later, Paul McFarlane of the *Sporting News* found a discrepancy in the tabulation for one game and declared Lajoie to have won the title, .383 to .382. The commissioner at the time of McFarlane's discovery, Bowie Kuhn, ruled that the old figures were to stay. As for the Chalmers, in its wisdom regarding public relations, the Chalmers Automobile Company gave cars to both Cobb and Lajoie and apologized to the public for the stir its prize had caused. Ban Johnson forbade the awarding of prizes for all future batting crowns.

# Napoleon "Larry" "Nap" Lajoie

## An Injury That Caused a Permanent Change to Baseball

Lajoie suffered numerous injuries during his playing years. Some were of his own doing, like the time he punched a wall when attempting to hit a player during a fight. Others were common injuries that occur to all players who play hard. Many were from spiking. Spiking by an opponent was common and could be very serious before the advent of penicillin. On July 1, 1905, Lajoie received a spike wound to his ankle. He played the whole game, but developed blood poisoning from the blue dye used in the stocking. Doctors feared they would have to amputate, but Lajoie persevered. Gradually, Lajoie recovered; however, he did not return to duty in any significant way for the rest of the season. Lajoie's injury resulted in players adopting white stockings and colored stirrups, a tradition still upheld by many teams today.

## The Silver Dollar Horseshoe

Cleveland fans adored Lajoie, and many felt that he had rejuvenated Cleveland baseball's glorious tradition. Prior to Lajoie's coming, Cleveland had been host city to Major League baseball for most years between 1879 and 1899. Some of the teams were pretty good, but many were of the losing persuasion. In fact, Cleveland holds the distinction of having hosted the worst Major League team in history—the Cleveland Spiders of the National League. Just prior to the Spiders' move to St. Louis in 1899, Cleveland owner Frank De Haas Robison discharged many of his best players to other teams, and the near-winless Spiders went 20 and 134 for a .130 winning percentage. This embarrassment, from a fan standpoint, was extra hard, given that the Spiders had produced one of the greatest players ever in Denton T. "Cy" Young. The press and fans were merciless, calling the team the Misfits, the Leftovers, the Discards and the Castoffs. Einstein's famous law of physics states that "for every action there is an opposite and equal reaction," and so it went for Cleveland. From the total disgust of the 1899 National League team came an equal and opposite reaction to the newly formed American League team, with its bona fide superstar Napoleon Lajoie. The love affair did not end, even after his departure in 1914. Perhaps their greatest display of tribute to Nap came in 1912, with the presentation of the now famous "$1,000" horseshoe.

Lajoie became one of the most recognized men in Cleveland. To show their appreciation for his commitment to the team and the city, Cleveland fans collected funds and created the "1,000 silver dollars" (1,009 to be precise)

# RHODE ISLAND BASEBALL

"Horseshoe of Silver Dollars." Lajoie Day, Cleveland, June 4, 1912. *Photo by L. Van Oeyen. Library of Congress.*

# Napoleon "Larry" "Nap" Lajoie

horseshoe and presented it to him on a special day. Cleveland displayed its gratitude on June 4, 1912, as it had for no other dignitary in the city's history. In addition to the horseshoe of silver dollars, Lajoie's teammates contributed another $125, a tidy sum from players' salaries at the time. The Naps topped off the "Lajoie Day" by beating Boston five to one, with Lajoie knocking in the first run and going two for three.

## THE END OF A LONG AND GLORIOUS CAREER

The year 1913 was Lajoie's last good one in Major League baseball. He had 465 at-bats, hit .335 and led the league in fielding average. After the 1914 season, he was sold to Philadelphia—back to Mack and the city where his career began. In 1915 and 1916, his defensive and offensive skills continued to deteriorate, despite a rigorous self-designed and motivated training program. He left Major League ball for good after the 1916 season. (He retired with some distinguished company that year, when Christy Mathewson, Mordecai Centennial "Three Finger" Brown, Nap Rucker, Rhoey Wallace and Honus Wagner all announced retirement. Both Wagner and Wallace would later come out of retirement for an abbreviated season.) "King Larry," however, was not finished with organized ball completely.

On January 15, 1917, the American Association Toronto Maple Leafs announced that they had chosen Nap Lajoie over Chief Bender to manage the club for the 1917 season. At the time, war raged throughout Europe and the continuation of baseball was very much in question. Lajoie believed that baseball would continue and opened up spring training at the end of March. Only six players showed up—an ominous start to what turned out to be an extremely successful season, both personally and for the team. Before long, Lajoie managed to assemble a good cast of players. Lajoie finished the season leading the league in hits (239), doubles (39) and batting average (.380). The Maple Leafs took the pennant by one and a half games over Providence, which was managed by Rhode Islander and former Major League player/umpire Jack "Rip" Egan. Even though the success was sweet for Toronto, the relationship between the Maple Leafs' front office and Lajoie soured. Nap did not return the following year. Instead, after being turned down to serve in the army, he would play out his last season in baseball as the manager of the Indianapolis Indians.

# 1918

## *War and the End to a Marvelous Career*

Lajoie was welcomed with much fanfare and excitement when he came to Indianapolis in 1918. Local papers referred to the team as the "Indianaps." The Indianapolis Indians had won the American Association Pennant in 1917 and represented a long and glorious baseball tradition in Indianapolis. The city had been host to professional baseball of one variety or another since 1884, including six years of Major League ball in the American, National and Federal Leagues. The thought that the great Lajoie would be at the helm of their beloved Indians was met with great enthusiasm by local residents. However, the 1918 season was dramatically affected by the desolation and despair of the realities of war. Honoring the request by the army, the Indians held their very limited spring training at Hattiesburg, Mississippi, ten miles from Camp Shelby, so they could play games against army servicemen. This was designed to boost the men's morale at the camp prior to being shipped overseas.

Baseball was having a rough go of it during the 1918 season. Most of the players exchanged their white wool baseball uniforms for the green woolen variety of the army. Many, like Lajoie, attempted to join, but were refused due to age, classified as "unfit for service." Within the first few weeks of the season, Lajoie lost nine of his players to the armed forces. Other leagues found themselves in the same boat. By mid-June, several leagues had disbanded play. War Secretary Newton Baker's edict, "work or fight," further decimated the ranks.

The Indianapolis Indians, along with the American Association, disbanded on the same day that the attack off Cape Cod occurred. At the time, the Indians were in third place and three games back. They had closed a considerable gap in July, going ten, one and one, with Lajoie hitting at a .349 clip during the streak. The pennant chase and minor league ball as a whole became a moot point after the German submarine attack on the American tug and barges. Lajoie's baseball career also came to an end on July 21. He never again managed or played in organized ball. Lajoie was offered the presidency of an Ohio/Pennsylvania semiprofessional league in 1919, but he refused.

Lajoie had a good head for business and signed on with the Miller Tire Company, and later with the Seales Rubber Company. He did very well financially and died at the age of eighty-four in Daytona Beach, Florida. His only business regret was that he didn't take up Ty Cobb's invitation to invest in a fledgling young company in 1910. The company of which Cobb would

# Napoleon "Larry" "Nap" Lajoie

eventually become chairman of the board was the Coca-Cola Company. If he had taken Cobb's advice, Lajoie would have been a multimillionaire.

Napoleon "Larry" Lajoie was elected to the Baseball Hall of Fame in 1937. Along with fellow Hall of Famers, Duffy and Hartnett, Lajoie is listed among the one hundred greatest players in *Total Baseball V.* Lajoie still holds the American League record for the highest batting average, with .426 set in 1901. To his credit, Lajoie had 3,242 Major League career hits and retired with a .338 batting average.

CHAPTER 11

# FREDERICK EUGENE "GENE" STEERE

*"The Kid"*

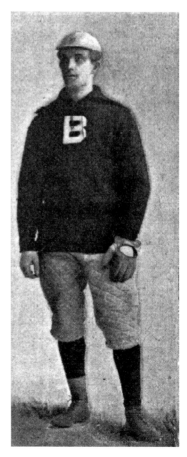

Born: August 16, 1872, at Scituate, RI
Died: March 13, 1942, in San Francisco, CA
Height: NA
Weight: 118 lbs.
Major League debut: August 29, 1894
Final game: September 25, 1894
Batted: right
Threw: right

## FROM SANDLOT PLAYER TO COLLEGE ALL-AMERICAN

Gene Steere never played organized ball until he went to college. Baseball was a game of love for young Steere as he joined other boys in countless sandlot games. As a child, he could not have predicted that the game of baseball would be such a large part of his identity throughout his life. Prior to entering Brown University, Steere attended Johnston High School, which did not field an organized baseball team. In fact, his senior class was only the second class to graduate from the newly formed school, and he was the first Johnston alumni to enter college.

Eugene Steere. Harper's Weekly, July 7, 1894. Author's collection.

# Rhode Island Baseball

After his senior year at Johnston High, Steere enrolled at Brown University in the fall of 1890 and joined the freshmen baseball squad, where he was immediately elected captain. Within the first week of practice, he caught the eye of the varsity captain, "Abe" Mendenhall. Mendenhall rather assertively encouraged Steere to start practicing with the varsity club due to a shortage of infielders. The catch was that he would have to switch from shortstop to second base. Excited about the opportunity to play with the varsity, but unhappy about the switch, he reluctantly agreed. First on Brown's schedule was a game with rival Harvard, whom Brown had not beaten in ten years. Every game with Harvard was considered historic, so on the day of the game a large crowd of Brown students went to Boston to support the team. Just before the start of the game, the gutsy Steere did the unthinkable for a freshman and approached Captain Mendenhall, asking to play shortstop because he felt uncomfortable playing second. As a matter of fate, the regular shortstop was unable to play that game and Steere got his wish.

The game with Harvard ended up being a thriller. Going into the ninth, the score was knotted at two up. Brown scored four runs in the top of the ninth and Harvard answered with two tallies in the bottom. The result: Brown six, Harvard four. This game was easily the biggest win in some time for Brown, and the supporters went wild that night, throwing a huge banquet at the famous Narragansett Hotel in Providence. Two players were credited with having saved the day. The infamous Fred Woodcock and a young scrapper named Frederick Steere. Due to his heroism in the game, Steere never had to fend off a competitor for shortstop at Brown again. Steere's newfound celebrity also attracted attention from Woodcock regarding his name. Woodcock, stating the name "Fred" would never do, christened Steere "the Kid" because of his youngish look and small stature. The nickname stuck throughout his baseball career.

While at Brown, Steere rubbed shoulders with some pretty talented baseball men, including Fred Woodcock (1891), who played several years of professional ball and is credited with the introduction of Nap Lajoie to the pros; and Fred Tenney (1894) and Frank Sexton, who both went on to distinguished Major League careers. Steere was coached by future Baseball Hall of Fame inductee and fellow Rhode Islander Hugh Duffy. His innate skills and exposure to some of the top talent in the nation culminated in being awarded the country's highest collegiate baseball honor of the time. In his senior year, he was named the starting shortstop on *Harper's Weekly* All-American College Baseball team. He was also the captain of the 1894 Brown team.

# Frederick Eugene "Gene" Steere

## The Pittsburgh Pirates and Professional Ball

Gene Steere's professional career was short and his Major League career was even shorter. He was up for a "cup of coffee" with Pittsburgh right out of college, playing in only 10 games. He continued to play for the New Bedford Whalers of the New England League through the 1898 season, although he played in only 6 games during the '97 and '98 seasons. He was primarily a shortstop during his professional career, playing a little second base and outfield. His best year was with the Whalers in 1895, when he batted .355, scored 108 runs and stole thirty-one bases in 79 games. The next year he played in 104 games and stole twenty-five bases, but his batting average dropped to .268. He threw in the towel after playing only one game in 1898 and then headed to the newly annexed territory of Hawaii to seek his destiny.

## The Islands, Baseball, Alexander Cartwright and Limes

The Kid packed his steamer trunk at age twenty-six and headed to Hawaii to make his fortune in coffee commodities. Coffee turned out to be a volatile proposition, and after a year of study he turned to the production of limes. Although his original intent was to return to the mainland after a few years, he fell in love with the customs, pace of life and diversity of the Hawaiian Islands. In a 1939 article published in the *Providence Journal*, written by Pembroke College graduate Eleanor Cost, Steere stated that he was totally enamored by the "hospitality" of the islands. As Steere put it, "We would stop at a house for lunch and often it was 10 days before our host would let us continue our journey."

Hawaii was composed of culturally defined segments of people from all over the world. Over the fifty years prior to Steere's arrival, sailors from many countries had visited the islands and decided to stay. Much to Steere's surprise, he found a well-developed system of baseball in Hawaii in 1898. Over the next forty years, Steere would contribute immensely to the further development of this system. By 1939, every nationality had its own team, the university team was very strong and Honolulu could boast having the greatest number of baseball teams of any city its size (250,000 residents). These teams competed for an Island Championship, which included such entries as the Asahi (Japanese) and the Haole (armed services and government). The 1939 champs were the Braves (Portuguese).

Although at first a mystery to Steere, it was no mystery to islanders how baseball had come to be in Hawaii. As Steere quickly discovered, Alexander

Cartwright was the "father of Baseball," twice—once on the U.S. mainland and once in Hawaii. Little known to many current baseball followers, Cartwright left the New York area within three years of establishing the rules for modern baseball. On foot, Cartwright traversed the country, teaching baseball to white men as well as Native Americans along the way. He arrived in California in August 1849, along with many other adventurers in search of gold. He quickly decided that the wildness of the gold rush was not for him and he sailed from San Francisco for New York via China. On the way, however, he became seriously ill and was put ashore in Honolulu to recover. He grew to like the islands so much that he decided to stay, and he lived out his life there. He was not idle. He immediately went about teaching the game of baseball to natives and the various groups who called Hawaii home. As a result, Hawaii became second only to the New York area in the development of early baseball and was considerably more advanced than the rest of the country.

By the time Steere came to Hawaii, baseball had been totally assimilated into Hawaiian culture. Steere spent countless visits discussing baseball with Cartwright's descendants and reading his diaries. What Cartwright had started, Steere continued and cultivated. He became, if not the father, then the overseer of baseball in Hawaii.

Before we leave the story of the Kid, let us return to limes. As stated earlier, Steere found coffee ventures too "venturous" to engage in. He developed a lime plantation and became very successful. After a few years, Steere went into real estate and did even better, becoming quite well off. What happened to Steere near the end of his life has not been easy to determine. Unfortunately, Steere's relatives were unsuccessful in providing any new information regarding the reason for Steere's departure from Hawaii sometime between 1938 and 1942. Steere had moved to San Francisco, where he died in 1942. His move may have been prompted by the attack on Pearl Harbor, ill health or poor business prospects.

Thanks to the San Francisco Department of Health, we do know how Eugene Steere died. According to *Vital Statistics*, Steere died of generalized arterial sclerosis, complicated by senile dementia due to myocarditis (hardening of the arteries). It is not all that important that we know the precise circumstances of the last couple of years of Steere's life. What is important is that we pay homage to his very interesting and fruitful time on Earth.

## Chapter 12

# Frank Corridon

### *Inventor of the Spitball*

Born: Novermber 25, 1880, in Newport, RI
Died: February 21, 1941, in Syracuse, NY
Height: 6' 0"
Weight: 170 lbs.
Major League debut: April 15, 1904
Final game: September 7, 1910
Batted: right
Threw: right

> To Jack Ryder,
>
> Corridon is a great pitcher, intelligent and willing. Has always been a winner in the spring and fall and if worked with good judgment, during the hot spell can deliver then. He is not a man of robust physique, and should not be used too often. I know of two American League clubs who would jump at a chance to get him. I should judge that he is a pitcher whom Griffith would make a better use than any one else because he is of the Griffith style of pitchers. He has always pitched his best against the best teams. He has excellent habits. Consider him Ewing's superior.
>
> J. Ed. Grillo,
> Washington, January 18.

## The Spitball

The above scouting report makes no mention of Frank Corridon's most memorable contribution to the national pastime—the spitball. Although

not well-known nowadays, the spitball was as popular in the early 1900s as the knuckle ball is today. Research has not provided the answer to how the spitball was thrown by Corridon; however, there appear to be several methods of throwing the "spitter." According to longtime Cranston resident and local baseball legend Neil Houston, the spitball pitch is performed by applying a large amount of foreign substance, such as "chew," on the ball just prior to release. The weight from the glob of guck causes the ball to take "sort of an elliptical rotation," resulting in an irregular flight path. The ball tends to drop "off the table" near the plate or acts in some other unpredictable way. Neil learned the pitch as a young man in the mid-1930s from an old-time ballplayer.

Whether Corridon was the actual inventor of the pitch is a matter of some debate; however, from my research, one can conclude two points of support for this theory. Corridon's name pops up in many sources as the inventor. The spitball has been associated with Corridon as early as the mid-1890s, predating any other discussion found in articles associated with the Major Leagues.

Local lore has it that Frank invented the spitball when he was a youngster playing sandlot games at the corner of Farewell Street and Van Zandt Avenue in Newport. Research performed by baseball historian Dick Thompson suggests a specific path the spitball took to get to the Major Leagues. According to Thompson:

> *Supposedly George Hilebrand, an outfielder for the Boston Braves in 1902, watched Corridon warming up by licking his fingers. They talked about it and the spitball made its "major league debut" shortly after. Hildebrand reportedly taught the spitball to Elmer Stricket, the other pitcher sometimes credited with the invention.*

Thompson also reports several other sources that strongly suggest Corridon was the inventor.

During Frank Corridon's career, the spitball remained "legal." In 1920, the pitch was outlawed by Commissioner Landis; however, the spitball and its derivatives remain in use even today. Ironically, accounts in local newspapers during Corridon's career do not even mention his use of the pitch. Although known as the inventor of the spitball, there is no indication that it was his primary pitch. Actually, according to contemporary accounts, his out pitch was a sneaky curve ball. Besides his pitching skills, Corridon was used by many teams as a center fielder, and in many years he hit over .300.

# Frank Corridon

## Discovery and Career

While playing for Rogers High School in Newport, Corridon's pitching drew the attention of Newport Colts' manager Mike Finn, who signed Corridon for the 1899 season. (The Colts was part of the professional New England League.) Not impressed with Frank's ability, Finn released Corridon early in the season. He was quickly signed by Pawtucket of the same league. Corridon had the pleasure of coming to Newport, with loud cheers from the locals, and defeating the Colts later that summer.

In 1900, Frank signed with the Eastern League Providence Clamdiggers, also known as the Providence Grays throughout most years of their existence. That year he was farmed out to Norwich of the Connecticut League, where he went fifteen and three. By 1901 he was playing full time with the Clamdiggers, pitching in thirty-five games and winning seventeen. In 1902, Corridon had perhaps his best professional year, leading the Eastern League with twenty-eight wins.

In 1904, Corridon was signed by the Chicago Cubs and later traded to the Philadelphia As. He played in the Majors for a total of six years from 1903 to 1910, finishing his Major League career with the St. Louis Cardinals. Despite the impression given in the scouting report by Grillo, Corridon was not frail. In fact, he averaged 230 innings pitched per year in the Majors and was extremely durable. Over his six-year Major League career, his earned run average (ERA) was 3.02. His best Major League season was with the 1908 Athletics, when he won eighteen games, pitched 274 innings and sported a 2.46 ERA. Corridon followed this performance in 1909 with an eleven and seven record (.611 winning percentage) and a 2.11 ERA.

In 1911, Corridon moved on to Buffalo of the Eastern League. As a player/manager in Buffalo, he compiled an eight and eleven record while appearing in thirty-two games. The Buffalo Bisons ended the season seventy-four and seventy-five. In 1913, he managed the Springfield Ponies to a sixty and seventy record. Corridon retired from professional baseball at the end of season and opened a small store on the corner of Russell Avenue and Malbone Road in Newport. However, as we shall see, he certainly wasn't finished with baseball.

## After the Pros

In 1914 Corridon organized and played for the Newport North Ends, a semiprofessional team. When the United States entered World War I, he

coached the navy's Second District team stationed at the naval submarine station in Newport. The Second District team was composed of some excellent ballplayers, including Rhode Islander John Gilmore, who will have a write-up in a future volume. According to Gilmore's grandson, the Second District team was favored by Teddy Roosevelt, who frequented home games in Newport at the old Wellington Avenue ball grounds. The team was so good that the navy, which could only support one team in the Northeast, chose the Newport team over Boston's First District team. Roosevelt was responsible for the development of the Second District team, which he hoped would improve public relations between local residents and the booming population of navy personnel caused by the war. The assignment of local hero Frank Corridon to coach the team was no accident. Everyone loved Frank and, as evidenced by local news coverage of the team, relations definitely improved.

After the war, Corridon returned to his roots, coaching the Rogers High School team for several years. No matter where his baseball travels took him, Frank always returned to Rhode Island. Although he died in Syracuse, his body was returned to Newport for burial. Not only is Frank held in high esteem both locally and nationally for his contributions and accomplishments in baseball, but he also remains the only Newport native son to play in the Major Leagues. Newport honored Corridon by naming a street after him that abuts the old Freebody Ball Field, where he began his professional career. A little behind the Newport Tennis Hall of Fame you will find Frank Corridon Avenue.

## Part III
## The Teams

Humanity is the keystone that holds nations and men together.
When that collapses, the whole structure crumbles.
This is as true of baseball teams as any other pursuit in life.
—Connie Mack

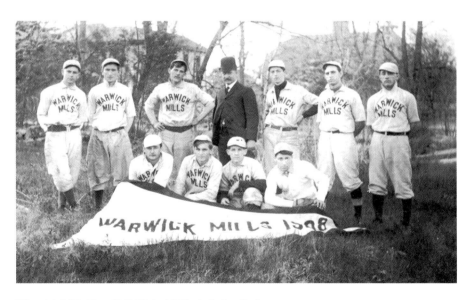

Warwick Mills Base Ball Club, 1908. *Author's collection.*

## Chapter 13

# Island Park and the Comets

For over two years I searched for the place called Island Park in Woonsocket. According to local newspapers of the time, a brand-new, state-of-the-art stadium had been built for a team called the Comets in the spring of 1883. One major problem related to researching this magnificent park had to do with the fact that there currently is no island large enough in present-day Woonsocket to house a baseball stadium. To confuse matters further, local historians and current residents refer to an area called "the Island" that is located just behind the present-day Museum of Work and Culture. This island is definitely too small for a ballpark. As research continued and information piled up regarding the Comets and their spectacular play, other research involving much later Woonsocket teams contained references to Island Park as being home to an annual traveling circus. With mention of the circus, older residents interviewed began to remember a place called Island Park.

The first real breakthrough came from the late Mary Longtin, a volunteer at the Museum of Work and Culture. Mary remembered the circus and walking bridge (the Edwards Street Footbridge) that crossed the Blackstone River connecting Sayles Street and Island Park. Mary used this bridge, as did others, to get to work at the old U.S. Rubber Plant (previously the Woonsocket Rubber Company and currently Tech Industries, Inc.) on Fairmount Street. Workers referred to the place at the end of the bridge as Island Park. When the ball field was constructed in 1883, the Woonsocket Rubber Company complex had not yet been built, and Fairmount Street did not exist. This left plenty of room for a ballpark, bleachers and refreshment tents. (Ice cold lemonade, five cents a glass, and foodstuffs were often sold during the game from temporary tents pitched for that purpose.) From a research point of view, one big question continued to loom: why was the area referred to as Island Park? Clearly, the area was not an island.

The information breakthrough that helped resolve this mystery came during a quick research stop at Memorial Public Library in Chepachet. The library has an 1870 survey map of Rhode Island. This map clearly demonstrates the existence of a canal that began just at the bend of what is known as the Bernon Pond section of the river and transected through Fairmount Street and the current parking lot of Tech Industries, Inc. The canal was confirmed by an earlier map of Woonsocket Falls from 1838 that demonstrates an even more dramatic picture of the canal, which almost cuts clear across the area, creating an island. The illustrations below show how the land looked during the nineteenth century and clearly demonstrate how the area could have acquired the name Island Park.

The passing of the ballpark was as quiet and slow as its birth was fast and exuberant. If you walk the area today, you can almost feel the presence of the old-time ballplayers and imagine the layout of the field as you approach the river. It is a place that echoes the eons of time and leaves you with an eerie sense that something special once happened there. Standing in center field, you can face home plate and envision the crowds that sometimes exceeded twenty-five hundred. The Island Park area remains largely undeveloped to this day and one may ask, "Why isn't the Grand Old Game still played here?"

The answer lies beneath your feet. When the field was built, the ground was solid and disturbed only by the occasional winter and spring floods. When the canal was filled in 1889 to make way for Fairmount Street and the Woonsocket Rubber Company, there was no place for the groundwater to drain. The canal gave the land a chance to stay dry. Without it, the land became spongy and unsuitable for ball playing. The last record of the park's serious use as a ball field is found in a 1908 news article that refers to the park in a reluctant fashion: "The old Island Park Field will be used by several Mill

Changes in the Island Park area from 1838 to 1895. *Drawn by the author.*

# Island Park and the Comets

League teams until repairs can be made to the Clinton Oval." Long before 1908, however, the park had been all but abandoned and no record could be found of its use by an important team after 1889, just six years after its exciting inauguration. Undoubtedly, the filling in of the canal brought doom to the field. The Comets, for whom the stadium was built, met a fate similar to the ballpark. The Comets quickly rose to perfection and faded just as quickly into history.

## THE 1883 COMETS

### Woonsocket's First Great Team

How great of a team was the Comets, a team that began in 1879 and disappeared shortly after the beginning of the 1884 season? Perhaps the following statistics can help answer this question.

The 1883 season was the only complete season for the Comets. The Comets played a known total of thirty-four games in 1883. (There were four games scheduled for which no records of play could be found—these would have brought the total games played to thirty-seven.) Of the thirty-four recorded games played, the Comets won twenty-eight and lost six, an impressive .824 winning percentage. Like many teams that existed in the 1880s, the Comets played a mixture of college, amateur, semiprofessional and professional teams. During the 1883 season, the Comets scored 408 runs, while giving up only 136. They averaged 12.3 runs a game, while their opponents could only muster 4.1 runs. Of the six losses, four came against National League teams. One newspaper column many years later claimed that the Comets were the 1883 champions of New England; however, no corroboration of this claim could be found.

Research indicates that the Comets was most likely a semiprofessional team. In the Comets' short history, the team disbanded twice because of poor financial conditions. If the team had been strictly amateur, financial troubles would have been unlikely, given the local support the team received. Other factors suggesting the team was semiprofessional include: 1) the majority of its games were played "at home," suggesting a need for a higher gate return to support the team; 2) teams of all levels were willing to travel to Woonsocket to play the Comets, indicating some sort of profitable arrangement; 3) the Comets solicited assistance from amateur, as well as professional, players from around New England, such as Ed Daily (Ed Daily was a professional player with the Providence Grays in 1883 and later for the Washington Senators); and 4) when the team disbanded due to financial constraints at

# BASE BALL.

## COMETS' NEW BALL GROUNDS,

### SATURDAY, MAY 26,

## Comets vs. Ashtons.

### TUESDAY, MAY 29,

## PROV. GRAYS

### vs.

## COMETS.

Grand Reception to the Providence Nine on their return from the West. This being their first game of the season in Rhode Island, lovers of the game should be present in force.

### Game Called at 3:30.

Admission, 25 cents; Grand Stand, 10 cents extra; Ladies free.

Woonsocket, May 22, 1883.

Advertisement for the "new Comet Gounds," as well as a game with the National League Providence Grays. Woonsocket Evening Reporter, *May 25, 1883.*

the end of the 1883 season, almost all of its players were quickly "signed" by other New England professional teams, leaving the 1884 team starting with a whole new cast.

The original Comets came into existence sometime in 1879. The first written reference to their existence, however, was a benefit held for them at the Woonsocket Music Hall during the week of June 16, 1882. Unfortunately,

# Island Park and the Comets

local papers did not cover the Comets between 1879 and 1882, except for a few games in September of '82. In 1883, however, the press diligently covered the Comets in great detail. Their first game of the great 1883 season was an exhibition game against the Perrys (Perry Commercial College of Providence). The Comets won twenty-three to three.

The Comets were great from the very first game and never looked back. In fact, it is hard to find a weakness in this team. They exhibited great offense and equally great defense. Perhaps their greatest virtue was the pitching. During the 1883 season, the Comets used four pitchers, Powell, Barton, Kelly (first names unavailable) and William Miller Vinton. Their ace was Vinton, who went twelve and three. All three of Vinton's losses came against National League teams. Barton was next, with six wins and no losses. He also made several relief appearances, as did Vinton. Powell was used early in the season, but not after the midpoint. His record was eight and two. Kelly was pressed into service for one game, beating the Millburys ten to six. Throughout the summer and fall of 1883, the team played excellent defense, usually making fewer than five errors a game, a feat that was considered admirable during the time of barehanded fielding. (Vinton was signed by Philadelphia in 1884 and pitched for two years in the Majors. He died in 1893 at the age of twenty-eight while living in Pawtucket.)

During the 1883 season, the Comets not only enjoyed success in the win/lose column, but also at the gate. Most games had five hundred to a thousand spectators and sometimes as many as twenty-five hundred. Admission was twenty-five cents for men, ten cents for children and "ladies" were always admitted free of charge. In addition to the occasional charitable benefit, the Comet Baseball Association also sponsored an annual excursion to New Rocky Point. Rocky Point wasn't actually new, nor was baseball at Rocky Point. Every amateur and professional team in Rhode Island played, at one time or another, at Rocky Point. In the later years, the minor league Providence Grays (Clamdiggers) played Sunday games at this park due to Providence's Blue Laws.

Despite excellent home support, the Comets experienced serious financial woes in 1883, disbanding and reorganizing twice. The final curtain call for the Comets came early in August 1884. Local papers, for an unknown reason, did not cover the 1884 team, which was sponsored by a local apothecary and was known as the OSRC team. OSRC was a trademark for the locally produced Orcutt's Sure Rheumatism Cure. Although this team had a totally different cast of characters than the 1883 team, it apparently continued the winning tradition, as was reported in the August 8, 1884 edition of the *Burrillville Gazette*: "The O.S.R.C.s were playing a very strong game, having

won a large majority of the games played." The OSRC team disbanded in early August. Local reports indicate that the players were immediately signed by other New England teams. The OSRC's best pitcher, Ed Conly (Conley), signed with the National League Providence Grays for the remainder of the 1884 season and went four and four, with a 2.15 earned run average. (Conley remained in Rhode Island after playing for Providence and died while living in Cumberland in 1894.)

Woonsocket would host a number of other average-to-good teams in the next few years (many would take the Comet namesake); however, the city would not see another great team until the 1892 minor league Woonsockets, who won the New England League Championship that year.

CHAPTER 14

# THE 1892 NEW ENGLAND LEAGUE PENNANT WINNERS

### *The Woonsockets*

Woonsocket has been host to four professional teams. The first and most successful of these teams was the 1892 Woonsockets. This team was composed of some of the best local and New England talent, with several players going on to have long and prosperous professional careers in both the minor and Major Leagues. For much of the 1892 season, the Woonsockets dominated all challengers for the championship.

## THE BEGINNING

Woonsocket had been playing baseball since the mid-1860s and had fielded many very good teams, most notably the 1883 semipro New England champions, the Comets. The Comets and other good teams built the foundation in Woonsocket to support a professional organization. A strong showing of support was necessary because in the early days of baseball, as it is now, no city could expect to draw big-name baseball players or host a professional franchise without the backing of key community leaders and a belief that fans would support the team at the gate.

By 1891, a version of the Woonsockets had developed that sported a serious group of local players. In the spring of that year, the Woonsockets began playing with the teams that had been part of the well-organized and prestigious professional Rhode Island League that disbanded at the end of the 1890 season. The Rhode Island League was a nonsignature professional league that rivaled many other small minor leagues around the country. ("Nonsignature" refers to the fact that the Rhode Island League was a professional league, but was not part of the Tripartite Agreement that governed the relationship between partner Major Leagues and minor

The only known image of the 1892 Woonsockets, champions of the New England League. Woonsocket Patriot, *July 20, 1892.*

leagues.) By midseason, the Woonsockets had joined the professional New England League. They were no match for the well-seasoned teams of the New England League. However, playing teams of this caliber did set the stage for the 1892 season, and one player on the '91 Woonsockets, Captain Walter Sweeney (first base), stood out and became a cornerstone on the 1892 team.

## THE "NEW" NEW ENGLAND LEAGUE

The 1892 version of the New England League formed rather late for the 1892 season. The first organizational meeting was held on March 30 at the Tremont House in Boston. Teams represented were Boston, Portland, Salem, Manchester, Lewiston and Worcester. Newspapers announced that chances were good for Woonsocket to become part of the league. The league continued to develop its base, as demonstrated in the following announcement, which appeared in the *Woonsocket Patriot* on April 15, 1892:

# The 1892 New England League Pennant Winners

*New England League*
*Applications for Positions on the Nines Rapidly Coming In.*

Application for positions in the New England League continue to pour in, and good nines can be signed for the [team] salary limit, $900. Some players have sent in teams as high as $125, but not a player in the league will receive a salary of over $90. As each club will be allotted eleven men, it will be seen that this will be about $80 per man. Players who have made a reputation on the ball field can expect the limit, but those who have yet to make a reputation on the diamond must expect to take a small salary as a starter.

The secretary J.C. Morse of the *Boston Herald*, is ready to send blanks for signatures to those who send him satisfactory terms, together with previous records and references.

In signing men the preferences will be given to New England players, and such of those as desire to play in the clubs of the city or town in which they live and will have an opportunity so to do by applying to the manager of the club.

Managers of clubs now in the circuit are requested to send to the secretary, as soon as possible, the names of such players they would like to see signed, together with the salaries they would be willing to pay them had they the opportunity.

## THE FORMATION OF THE 1892 WOONSOCKETS

The Woonsockets had been part of the 1891 New England League and very much intended to play in the '92 version of the New England League. By April 25, the team was ready to report to the league secretary. The following short article appeared in the *Woonsocket Evening Reporter* on April 25, 1892:

*Manager Gay hustling*
*Makeup of the Woonsocket Team Will Be "One of the Finest."*
*Manager Gay of Woonsocket Is Hustling for Good of the Cause.*
The Woonsocket team will be in the city Thursday and probably again Saturday. The following will be men and their positions: Capt. Sweeney will be here again and play first and captain the club. Then there will be Burrill as catcher, who played last year with the New York league team; Webster, also a catcher, formerly with Portland; McGrath, shortstop, who played with Lowell; Coakley, to play at second, last year of the New York

*state league team; Harrington, on third, of last year's team and a "coming man" Feen, the well known pitcher, is a possibility, and one the catchers will play right field. Watking, New York pitcher, is also engaged. On the whole Woonsocket has got one of the finest teams in the league.*

*Manager Gay goes to Boston tonight to attend a meeting and to see the Brockton management about Capt. Sweeney, and to get uniforms. All the teams have reported except Woonsocket.*

Woonsocket did report, and after several changes to the lineup, the team played its first game on Wednesday, May 5. The Woonsockets' unfortunate opponents were the Lewiston Gazettes. The game remained close through the first four innings with the Woonsockets leading the Gazettes six to five. In the next three innings, however, the Woonsockets put the game away, scoring nine runs. The final score was Woonsockets, seventeen, and Gazettes, nine. The team was off to a good start both on and off the field, with six hundred enthusiastic Woonsocket spectators in attendance at the old Agricultural Park. For the record, the winning pitcher was John Feen, who went the distance.

Baseball back in the late 1800s could be very interesting, to say the least, and the game had many on- and off-field distractions. Many of the players tended to be less than gentlemanly, as did officials associated with the game. One such interesting story of an inebriated umpire occurred in the second game of the season. Following is an excerpt form the May 6, 1892 edition of the *Woonsocket Evening Reporter* that both tells the tale and amply illustrates the writing style of the period:

*Rocky Umpiring By a Waltham Man*

*When umpire Conley appeared on the filed at yesterday's game his condition of inebriation was such that Captains O'Brien and Annis advised him not to go in. But Conley said that he had been assigned to umpire the game and insisted upon so doing. To avoid a scene, if possible, the captains agreed to allow Conley to start the game and to umpire it unless his decisions were too much warped by his seemingly befuddled brain. Conley sucked a lemon to stiffen up his voice and took his position.*

*Woonsocket came to the plate first, and Sweeney flied to Burns. Flack hit a safe liner to center, a couple of wild pitches sent him to third and he scored on Captain O'Brien's long drive for two bases. Then Coakley drove a slow liner which passed third base two feet on the foul side of the bag, and went eight feet beyond the base onto the*

# The 1892 New England League Pennant Winners

*diamond. Coakley started for first on the hit, but halfway down the base line was stopped momentarily by cries of "foul." Conley shouted "fair ball" and "Coak" ambled on to the initial bag, O'Brien taking third, Conley declared the big second baseman [Coakley] out for not running on a fair ball, and ordered him to leave the bag. Tom O'Brien from his perch at third said "Stay there," and Coakley informed Conley that he intended to obey his captain as against any umpire in the country. Conley walked up and looked as if he wanted to throw the runner off the diamond, but gazed at his proportions and wisely did not attempt the feat. Conley did not call "time" or shout "Play ball," but took out his watch and waited. Meanwhile Captains Annis and O'Brien were conferring. Conley told Tobin to pitch the ball, but the wily twirler stood immovable. After a time Conley declared the game a forfeit to the Portlands, 9 to 0, and Captain O'Brien entered a protest against the decision. Then Conley was invited to leave and Feen of Woonsocket and Klobedaz of Portland were pressed into service and umpired impartially and well for amateurs. Conley retired amid jeers and imprecations of the crowd, and in attempting to climb over the picket fence near the grand stand caught his trousers on a picket and badly damaged those useful articles. Ladd hit safely to right and O'Brien scored.*

Woonsocket went on to win the game five to four. No record could be found of Conley umpiring another game for the Woonsockets.

During the first month of the season (May), the Woonsockets sunk as low as fourth place; however, they finished the month in first place with a twelve and seven record. John Feen, Hi Ladd, William Condrey and Thomas Callery shared the pitching duties. In May, the Woonsockets had 227 hits, compared to opponents' 169, and outscored their rivals by 123 to 94. The city was ecstatic with the fortunes of its team, and one game boasted an attendance of three thousand—a huge crowd by the standards of the day.

By the end of July, the Woonsockets had a good record with thirty-seven wins and twenty-one defeats, but they were in second place. The Woonsockets opened August with a win and then went on a six-game losing streak. With their hopes of a pennant fading, the team took action and signed five new pitchers, four of whom had played or would play in the future, in the Major Leagues. The new pitchers included Bob Barr, who hailed from Washington D.C. and would go on to play five years in the Majors; John Frederick Kiley, from Dedham, Massachusetts, who had played for Boston in 1891; Rhode Islander Thomas Lovett, who would

pitch six years in the Majors; John Stafford, from Dudley, Massachusetts, who would pitch the following year for Cleveland; and Phillip Viau. Rhode Islander and future Major Leaguer Hi Ladd continued to pitch in relief. From August 11 on, the Woonsockets posted a twenty-one and six record clenching the pennant by six and a half games. The team ended the season with sixty-three wins and thirty-two losses. A gold-lined cup was presented to the team at Agricultural Park on September 18 by New England League Secretary Jacob C. Morse and General Arthur Dixwell of Boston.

Hope abounded for the next season, but fate intervened. Woonsocket did not enter a team in the New England League in 1893. Why the Woonsockets did not reorganize a professional team in 1893 remains a mystery. There is no documentation for this decision evidenced in the two major Woonsocket newspapers. The professional team simply disappeared; however, a semiprofessional team with the same name did play in 1893 and was captained by Frank Sweeney from the 1892 campaign. In the upcoming years, several more semiprofessional teams would take the name Woonsockets, and many of these teams were very

Agricultural Park, home field to the Woonsockets. Woonsocket Patriot, *September 9, 1892.*

# The 1892 New England League Pennant Winners

good. On one such team, Rhode Islander and future Hall of Famer Nap Lajoie played in 1894.

As for professional ball, Woonsocket would not see another professional team until the ill-fated 1908 Woonsocket Trotters (Prodigals) of the Atlantic Association. This team holds the unique distinction in professional baseball as being the only team to have a losing season, zero to one, without playing a game.

CHAPTER 15

# THE 1914 PROVIDENCE GRAYS

The International League Providence Grays, also known as the Clamdiggers in earlier years, enjoyed much success in the early 1900s, winning two pennants and generally yielding competitive teams. But not since Hugh Duffy's 1909 team had they posted a wining record, and in fact they finished in the cellar three years straight from 1910 to 1912. It did not seem to matter during these years who managed the team. (Managers included Hall of Famer Jimmy Collins and well-known Fred Lake, discoverer of Nap Lajoie.) In 1912, Wild Bill Donovan took over from Lake and began to right the ship. In 1913, Donovan's team went sixty-nine and eighty for the season, but still finished twenty-four and a half games back. Despite these bleak years, the press spoke optimistically about the Grays as they moved south to Savannah, Georgia, for spring training in early March 1914.

Manager Donovan had only assembled thirteen players by the time they played their first exhibition game in Savannah. The press jokingly challenged Donovan because it appeared that he was tempting fate by ignoring superstition. The game was played on Friday the Thirteenth, with thirteen Grays players and the Savannians had won their league's pennant in 1913. That's a lot of thirteens to overcome and, as it turned out, they didn't overcome ill fate on that day. The team lost its exhibition opener. Not phased by the loss, the Grays went on to win their next five exhibition games. Donovan used the time in Georgia to evaluate and assemble what he hoped would be a winning team. By April 4, the Grays had captured the "Swamp League Pennant." (The Swamp League was sort of like the Red Sox's Grapefruit League today.) The team took a little time off and headed north to complete the spring schedule. On April 11, the Grays played Brown University at Melrose Park, winning nine to six in front of a crowd numbering forty-five hundred. On the eighteenth, they took on

# RHODE ISLAND BASEBALL

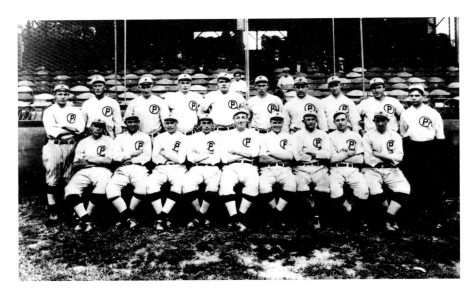

Providence Ball Club, champions of the International League, 1914. Ruth is at second row, center. Providence Journal *photo*.

the Fitchburg Burghers of the New England League at Fitchburg, winning thirteen to zero, in the morning, and in the afternoon in Worcester, they played the Worcester Busters of the same league, winning six to two. The next day it was down to Rocky Point for their final tune-up game.

There could be no doubt that the baseball season was about to open in Providence. The press was devoting much coverage to the impending season, and local newspapers were running numerous ads with baseball themes, such as one that ran on April 17, 1914, promising a ball or bat in exchange for "5 coupons" of Kirkman's White Soap.

On April 19, a large crowd of eight thousand gathered at Rocky Point to watch their beloved local team play Connie Mack and the 1913 World Champions—the Philadelphia Athletics. The game was much closer than the score indicated. Philadelphia won five to two, but the Grays coughed up four unearned runs in the loss.

The following day saw the opening of the 1914 season. The Eastern League was considered one of the premiere minor leagues. The number of Grays players who had or would in the future have Major League experience attests to this fact. There were thirty-nine players who filtered through the team in 1914. Of these players, eighteen spent one or more years in the Major Leagues, including Hall of Famer Babe Ruth, who had twenty-two

# The 1914 Providence Grays

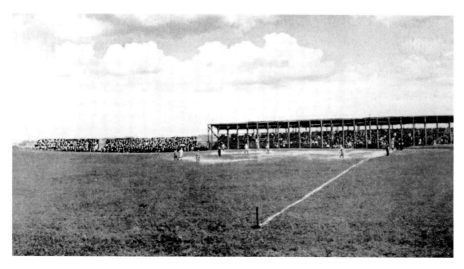

A large crowd at Rocky Point Baseball Grounds. (The team playing is likely the Grays in 1914.) Postmarked 1915. *Author's collection.*

years; Wild Bill Donovan, eighteen years; Matty McIntrye, ten years; and Rabbit Powell and Dave Shean, nine years each.

Bill Bailey got the nod to pitch the opener and went the distance for the win, five to four. The game was evidently very interesting, as suggested by an unidentified beat writer for the *Providence Journal* who took full opportunity to display his artistic bent to describe the game:

> *There was a slam-bang start with hits hopping off the bats in great profusion and runners scampering over the plate like mad, and the innings that followed yielded sharp batting and fast and loose fielding in sufficient doses to sustain the interest at a high pitch, but the thrilling climax of the game developed in the closing play and was worth all the rest of the harvest, put together in view of the fact the Grays utilized it in hanging the defeat on Joe Kelly's Canadian invaders.*

The ninth inning unfolded in the following fashion. The score was tied four to four. Bailey dispatched the visiting club in order. In the Grays' half of the frame, Bunny Fabrique walked to open the bottom of the ninth. Big Carl Mays was due up next. However, once Fabrique got on, Wild Bill ordered Jack Onslow to the plate. Onslow was instructed to lay down a bunt to move Fabrique into scoring position. The bunt was perfect. Tim Jordan, Toronto's

slow-footed first baseman, did successfully retrieve the ball, but he uncorked a wild throw. Speedy Fabrique took full advantage of the throw and scored on the error. End of game.

For the first month and a half of the season, the Grays were inconsistent and streaky, often wining three or four in a row and then losing three or four straight. By June 8, they were in sixth place with a .475 winning percentage. On June 9, big Carl Mays pitched a seven-hit shutout against Newark, triggering a five-game wining streak. Headlines reported: "Mr. Jinx Stays Away and Grays Win 1 to 0." For the remainder of the season, the Grays would lose three in a row only once and fashion several wining streaks of five or more. The winning was not without some luck, however, as evidenced by a game played on July 13.

Dave Shean was at bat in the eighth inning in a close game, with the Grays leading the Baltimore Orioles two to nothing. Providence felt they needed one more run, but did not expect the kind of help they were about to receive. Shean worked the count to two and zero. He then smacked a line drive that curled just past the Birds' first baseman Murray. Once past Murray, the ball rolled into foul territory near the outlet advertisement sign. Shean took off around the bases, no doubt thinking double. When Murray failed to come up with the ball, Shean continued on to third and then home for an inside-the-park home run. Murray continued to look dumbfounded, standing where the ball should have come to rest. No one knew where the ball had vanished until after the game. The trickster responsible was a rabbit who had dug a hole just beside the outlet sign. The ball had taken a convenient roll into the hole and disappeared. By today's standards, the hit would have been ruled a true ground rule double, but back then it was the rabbit's day to shine for the home team. The Grays won the game three to zero.

By mid-August the Grays were in first place, with a game-and-a-half lead over Rochester and a three-and-a-half-game lead over Baltimore. The pennant was by no means clinched, even though they had won twenty-two out of their last thirty games. Then, along came a young fellow named George Herman Ruth, who had been sent down by the Boston Americans. On August 22, Ruth made his debut for the Grays, pitching a victory against the Rochester Hustlers, five to four. On August 26, Ruth lost to the Buffalo Bisons two to eight. He was hit extremely hard. Based on this game, the press expressed great concern that perhaps this young fellow was just another "flash in the pan." Ruth would disprove these critics by snapping off five straight victories. By the end of the season, Ruth had ten victories to two losses, quite a feat given that he only joined the Grays in mid-August. Of special interest to Rhode Islanders, most researchers attribute Ruth's

# The 1914 Providence Grays

nickname, "Babe," to his career in the Majors. However, it was coined by the Providence press first, as evidenced by coverage of the game on August 26: "Babe Ruth, the former Oriole, who brought joy to the record crowd at Providence last Saturday…"

Ruth was a major factor in the Grays winning the pennant. By September 15, the Grays were one game behind the league leader, Rochester. Then the Grays poured it on, winning eleven out of their next twelve games, with Ruth winning four of the games without a loss. (Ruth's pitching was the margin of their success, with the pennant won by four games.) After Providence clinched the championship, they had to play one more game to complete the schedule. The game was against their rival, the Baltimore Orioles, who had originally sold Ruth to Boston earlier in the summer. The Orioles were being managed by Dunn, who had managed the last Providence team to win a pennant in 1905. The game was not taken seriously by either team. In fact, after the game, the press labeled Providence the "Goof Grays." The teams combined for fifty-four hits and forty-eight runs, with Providence wining twenty-three to nineteen. Perhaps the most spectacular statistic of the game is that it lasted one hour and forty-five minutes, which the press vilified as too lengthy. (How long would a game that sported fifty-four hits and forty-eight runs scored last today? Six hours?)

The players of the 1914 Grays were awarded with a grand "Baseball Night" held at the YMCA in Providence. Each player was presented with a gold watch fob, and Wild Bill Donovan was given a silver winner's cup. Several big theatre names showed up to perform baseball comedy routines that apparently were greatly appreciated by the audience. Mayor Gainer led a cheer on Donovan's behalf, and according to the press, the crowd became so wrapped up in the cheer that control could not be established for several minutes. The night was the biggest celebration for a Providence professional baseball team in history. It would also be the last. Providence would never again host a pennant-winning professional baseball team. Even though many more professional Providence Grays teams would play right up through the 1949 season, none could boast a pennant. The 1914 Providence Grays represent an end to a glorious legacy of champions that began with the 1879 Providence Grays National League Champions.

## A Mystery Solved (Almost)

While performing research for the 1914 Providence Grays' chapter, I discovered an advertisement in the *Providence Journal*. It proved to be a

noteworthy puzzle to solve. What technology existed at that time that would allow for a visual simulcast with audio narration in Providence for a game being played over 450 miles away in Buffalo, New York? Initial research provided few answers. Commercial wire photo technology was first used in the early 1920s and was in full swing by 1925. But this technology was different than the technology used by the Coleman Life-Like system. We have two sources to thank for helping us solve this mystery: Dick Bendicksen and Nomi Krasilovsky. Mr. Bendicksen is the curator at the Museum of Communications in Seattle, Washington, and Ms. Krasilovsky is a research librarian at the Providence Public Library. The following information is garnered from these two historians, to whom we are indebted.

## BASEBALL! BASEBALL!!

**To play Providence Away from Home—One Week Only Starting Monday with Buffalo, August 24th, at 3 P. M.**

### Greatest Invention Since Wireless Telegraphy
## COLEMAN LIFE-LIKE BASEBALL PLAYER

You see every play as it is made upon the field with pictures of players that hit the ball, run the bases, get put out or slide to safety. The ball sails through the air, players run, catch or pick up ball, and make the play. Umpires give decisions. You see errors, fumbles, wild throws. In fact it is just like being at the game. FANS SAY MORE INTERESTING.

### BRING THE LADIES

**Nothing Like It in the World. Direct Wire from the Ground**

## PROVIDENCE OPERA HOUSE

### ADMISSION 15c. AND 25c.

### SPECIAL

Every Evening at 8 O'Clock an Exact Reproduction of the Game Played by the Boston Braves and Chicago at Chicago—SAME ADMISSION.

Advertisement for the "Coleman Life-Like Baseball Player" *Providence Journal, 1914.*

# The 1914 Providence Grays

The first patent for a facsimile was by Alexander Bain in 1843. It does not appear this technology went too far. The fellow we are most interested in was one Arthur Korn, a German physicist who developed a "fax machine" in 1902. The technology used in the above program most likely was based on Korn's work.

One small mystery remains. The advertisement indicates an almost "motion picture" quality—"the ball sails through the air." The technology to transmit moving pictures definitely did not exist at this time, so one must assume that the effect was created by displaying several photos in sequence to give the illusion of movement. At any rate, the advertisement was probably true to its statement: "Nothing Like It in the World." It must have been quite a show.

Chapter 16

# The 1926 Sayles Baseball Club

### Champions of the Pawtucket and District Manufacturers' League

## A Little Background Information

In the first half of the century, manufacturers' and mill leagues were a primary motivator for baseball in urban and rural New England. By 1900, and continuing right into the mid-1950s, these leagues ruled the baseball cultural landscape of most Rhode Island communities. The Mill League in northern Rhode Island, the Tri-State League in the eastern part of the state and the Pawtucket and District Manufacturers' League are examples of the more successful of the company-sponsored leagues. In addition, there were several other lesser-known company leagues in southern, western and northwestern Rhode Island. The popularity of and support provided to these leagues were tremendous, and they made baseball an integral part of any factory worker's life. The home team was rooted for with great intensity, not unlike varsity high school and college teams today. Each victory was a matter of pride for the community, and each loss was the focus of many a barroom discussion.

The identities of many Rhode Island communities of the period were interchangeable with the major industries in the area. This is true for Saylesville, which is part of Lincoln. William F. Sayles bought a small print shop on Walker Street and Route 126 in 1847, and the Sayles empire was born. In 1863, Frederick Sayles was brought into the firm, and the business expanded to cloth dyeing in addition to printing. Throughout the nineteenth century, the Sayles family business expanded to include interest in some of the more prominent mills in Rhode Island, as well as ownership in the railroad industry. By 1901, the Sayles Bleachery was considered the largest in the world. About this time, a great interest in

# Rhode Island Baseball

"industrial psychology" was developing. Concepts included the use of time-motion studies, improved production methods and incorporating the workforce with a "sense of community." Industrial interests began to develop medical and recreational resources for their employees. However, social concern driven by profit motive generally does not mix. This theme would eventually spell doom for the community that evolved around the Sayles Finishing Plant. Before this occurred, however, many cultural and sports activities developed in Saylesville, including a very strong system of baseball enterprises.

Around the turn of the century, the first of a long line of baseball teams came into play at the old Sayles mill. The Pawtucket Intercity League developed to accommodate the interest among several manufacturing companies. The Sayles Baseball Club always did well in the league, winning several pennants from 1900 to 1929. Besides baseball, other social activities set up by the Sayles Finishing plant included soccer, bocce, noonday baseball leagues, dance, drama clubs, chess and checker leagues, bowling, fishing, tennis and much more. If one needed to see a doctor, he went to the company health clinic. The company even provided for a public library. Housing, hardware, household items and food were all managed by the company or by employee associations. Even women's

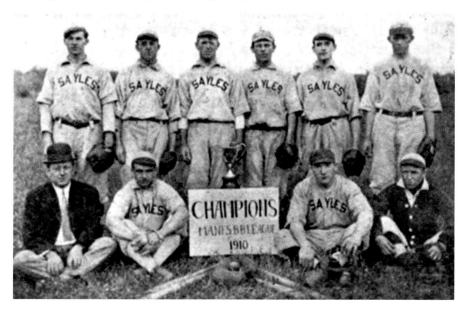

Champions of the 1910 Manufacturer's League. Sayles News, *August 28, 1920. Author's collection.*

## The 1926 Sayles Baseball Club

baseball was encouraged. Every opportunity to incorporate company life with community life was created. Although this may sound like a utopia of sorts, the effect was that somewhat controlling and competitive market forces were soon to be the undoing of the company community.

While the Sayles business trust was investing in its workers' community, it was also diversifying in other geographical locations. Besides owning several plants in Phillipsdale and Pawtucket, it began a major construction of the Sayles-Biltmore Plant in Biltmore, North Carolina, in 1925. This plant was heralded as the "newest member" of the Sayles family and was expected to be great for business. Reading from the company-owned newspaper, one picks up only positive accolades from the articles. However, the Sayles business concerns were not immune from the labor movement, which was going through a resurgence at the time. When the plants in Biltmore were opened in 1926, the *Sayles News* wrote that "some jobs" were going to be lost in Rhode Island. Management promised that every effort would be found to find work for its displaced workers and relocate key positions to North Carolina.

As baseball games were enthusiastically enjoyed by the players and the fans, working conditions and pay became increasingly more important to the everyday worker. When the Depression hit, the stage was set for a major union organizing effort. Early in September 1934, a nationwide textile strike was called. At first, the workers in Saylesville were reluctant to join. By the end of the first week, the movement become widespread in the South, where violence had erupted. In South Carolina, forty-one strikers were wounded and six were reported dead at a picket line on September 6. In Rhode Island on the same day, Governor Green ordered state troopers to disperse strikers in Warren with "bayonets fixed." Workers at Sayles Finishing Plant hit the picket lines. The strike spread quickly throughout the United States. By September 7, it was estimated that several hundred thousand textile workers around the nation were on strike, making it one of the largest organized strikes in history.

Back at Saylesville, the pickets grew in size and the threat of violence persisted as the plant remained opened. On September 10, Governor Green ordered that the picket lines be broken by state police. A riot ensued in which several strikers were seriously hurt and seven troopers were also injured. Headlines read: "Mill Workers Molested"; "Deputies Open Fire"; "Troopers Fight Strike Pickets at Saylesville"; "Three Wounded By Deputies at Saylesville, 1000 Stone Troopers For Two Hours." The level of violence was extreme and the event made national headlines. The next day, Green ordered the Sayles plants shut down. By the middle of the month,

the national strike was winding down with much violence in its wake. Victory was claimed on both sides. In Rhode Island, fifteen "communists" were arrested in Providence and the strike in Saylesville was blamed on "outside agitators." With extensive support from the National Guard and the state troopers, plants began to reopen. Sayles Finishing Plants opened for business on September 19. Although the company rebounded and maintained its prominence in the textile industry for a while, the Sayles family of textile companies began to shrink (no pun intended) until it ceased to exist in 1970.

Despite the "hometown" news and sunny outlook portrayed in the *Sayles News* during the 1920s, the relationship between management and workers was tenuous at best and good relations all but ended after the 1934 violence. It could be assumed that the opening of the South Carolina plant represented early planning and was an attempt by Sayles management to navigate around the textile organizing movement, which was not as strong in the South. The original Sayles site is now leased out to numerous tenants. The Sayles Finishing Company and its subsidiaries are known to be the foremost innovators in cloth preparation. Sayles created the first textile research facility and is credited with developing the "mercerizing process," which added strength and luster to fabrics (1898); processing textile without starch, which gave a lasting sheer finish (1917); developing the "anti-crease" process (1932); inventing a water-repellant fabric called Storm King (1943); and the introduction of the "Sayl-a-Set" finish to avoid shrinkage (1944).

## Now for a Story of the 1926 Saylesville Baseball Club

### *Opening Day (Not a Good Start)*

There were actually two opening days. The opening day that included the ceremonies took place on May 15. The real opening day was played on May 8. The season did not start well for the home team. In the May 8 game, Sayles looked to make it a laugher, with four runs in the bottom of the first. However, McKerley, pitching for U.S. Finishing, put up goose eggs for the final eight innings. Going into the eighth, the game was tied at four to four. Sayles pitcher Fred Turner had managed to keep the opposing team fairly off balance throughout most of the game. In the ninth, Turner was able to get two quick outs; however, he walked U.S. Finishing catcher Neville. Turner then gave up a hit that led to what would be the winning run by U.S. Finishing. Crosbie Tower relieved Turner and finished the inning

## The 1926 Sayles Baseball Club

without mishap, but Sayles was unable to score in the bottom of the eighth. U.S. Finishing won five to four behind the eleven-strikeout performance of McKerley. (McKerley had pitched Glenlyon to the Pawtucket and District Manufacturers' League championship by winning all of the World Series games against U.S. Finishing in 1925.)

The ceremonious opening day on May 15 saw Sayles take an early lead, three to one, only to be rained out after three innings. The impending weather did not dampen the spirits of the fans, however. A large crowd gathered at opening day and were treated to a host of festivities before the rains came, including a parade composed of players from both teams (J.P. Coats and Sayles) and several dignitaries. Music was provided by the Sayles Band under the direction of Walter Greaves. The "Star-Spangled Banner" was played and then R.D. Shaw, president of the Sayles Employees' Association, threw out the first pitch.

### *The Season*

Sayles begin the season one and two, beating the previous year's champion, Glenlyon, and losing to U.S. Finishing (Pawtucket) and Mount Hope from North Dighton. Initially, Fred Turner handled the mound for Syles, with John McCarthy pitching in relief. (The roles would reverse by mid-July.) Starting on June 5, the Sayles Club set off a string of eight straight wins, catapulting them into the lead. However, U.S. Finishing and Glenlyon would keep pace throughout the whole season. Glenlyon, being the perennial champ, was the main focus of all the teams. Write-ups of the games with Glenlyon were always of greater interest and longer in nature.

The 1926 version of the Pawtucket and District Manufacturers' League consisted of six teams. (It is important to note that the Pawtucket and District Manufacturers' League was also known as the Intercity League and Pawtucket City League in earlier years.) The Sayles family were principal owners of three teams in the league—U.S. Finishing (Pawtucket), Glenlyon (Phillipsdale) and Sayles (Saylesville). Also in the league were Mount Hope (North Dighton), Lonsdale and J&P Coats (Pawtucket). J&P Coats and Sayles both used Sayles Field as their "home grounds." Consequently, thirteen of the twenty-one games played by Sayles were at Sayles Field. The league was home to many good baseball players of the era. The most notable player was Rhode Island native Bruce Caldwell.

Caldwell played for the 1925 Sayles team and returned to the 1926 team after his semester was over at Yale, playing his first game on July 3. He was considered the best player defensively, at second, and offensively as well. Caldwell was definitely a major part of the championship drive down the

stretch. Not only was Caldwell good enough to play for the Yale Nine, but also after graduation he was signed by the Cleveland Naps (Indians) and played eighteen games in 1928. He surfaced again in the Majors in 1932, playing for the Boston Braves.

The last league games of the regular season were played on September 11. Sayles, U.S. Finishing and Glenlyon all won their games. This presented a first for the Pawtucket District and Manufacturers' League. Although there had been ties in the past and a playoff series was required to establish the pennant winner, there had never been a three-way tie. After a three-game playoff series, Sayles became the champions of 1926.

## *The End of the Story*

This chapter touched on a complex set of issues confronted by the millworker, representing conflict between the values associated with improving labor conditions and the Horatio Alger–style values ingrained in American culture. In the end, strong labor organizations did develop and workers made gains in health, longevity, pay and other worker rights. In 1995, the Amalgamated Clothing and Textile Workers Union merged with the International Ladies Garment Workers Union to create the Union of Needle Trades and Textile Employees (UNITE), which now boasts hundreds of thousands of members. However, from the 1930s to the 1980s, Rhode Island and the textile industry lost much from a labor standpoint via operations moving into unfriendly labor markets in the mid-Atlantic states and then to impoverished nations around the world.

# Bibliography

## Books

Acocella, Nicholas, and Donald Dewey. *Encyclopedia of Major League Baseball Teams*. New York: Harper Collins Publishers, Inc., 1993.

*The Baseball Encyclopedia*. New York: Macmillan Publishing Company, 1990.

*Beadle's Dime Base-Ball Player*. New York: Beadle and Company Publishers, 1867.

Bellerose, Robert R. *Images of America, Woonsocket*. Dover, NH: Arcadia Publishing, 1997.

Bourget, Paul A. *Towers of Faith: St. Ann's Church (1890–1990)*. State College, PA: Jostens Printing and Publishing Division, 1990.

Bronson, Walter C. *The History of Brown University*. Providence, RI: Brown University, 1914.

Brown, Elijah P. *The Real Billy Sunday*. New York: Fleming H. Revell Company, 1914.

Burns, Ken, and Geoffrey C. Ward. *Baseball: An Illustrated History*. New York: Alfred A. Knopf, 1994.

# Bibliography

Burrillville Historical and Preservation Society. *The Mills of Burrillville in 1894*. Self-published, 1993.

Carruth, Gorton. *American Facts and Dates*. New York: Thomas Y. Crowell Company, 1962.

———. *What Happened When: A Chronology of Life and Events in America*. New York: Signet, 1991.

Charlton, James. *The Baseball Chronology*. New York: Macmillan Publishing Company, 1991.

Clark, Dick, and Larry Lester. *The Negro Leagues Book*. Cleveland: Society of American Baseball Research, Mathews Printing, 1994.

Conley, Patrick T., and Paul Campbell. *Providence: A Pictorial History*. Norfolk, VA: Donning Company Publishers, 1982.

Dickson, Paul. *The Dickson Baseball Dictionary*. New York: Facts on File, 1989.

Ekin, Larry. *Baseball Fathers, Baseball Sons*. White Hall, VA: Betterway Publications, Inc., 1992.

Frost, Helen, and Charles Digby Wardkaw. *Basket Ball and Indoor Baseball for Women*. New York: Charles Scribner's Sons, 1920.

Gershman, Michael. *Diamonds: The Evolution of the Ballpark*. Boston: Houghton Mifflin Company, 1993.

Gershman, Michael, Pete Palmer, David Pietrusza and John Thorn. *Total Baseball*. New York: Viking Press, 1997.

Gettelson, Leonard. *1954: One for the Book, All-Time Baseball Records*. St. Louis: Sporting News, Charles C. Spink & Son, 1954.

*Guinness Book of World Records*. Guinness Publishing Ltd., 1997.

*Harper's Weekly: A Journal of Civilization*. 1857–1920

# BIBLIOGRAPHY

*Historical Catalogue of Brown University.* Providence, RI: Brown University, 1904, 1936 and 1950.

James, Bill. *The Bill James Baseball Guide to Baseball Managers from 1970 to Today.* New York: Scribner, 1997.

Johnson, Elizabeth J., Susan L. Reed and James L. Wheaton. *Images of America, Pawtucket.* Vol. II. Dover, NH: Arcadia Publishing, 1996.

Johnson, Lloyd. *Baseball's Book of Firsts.* Philadelphia: Courage Books, 1999.

Johnson, Lloyd, and Miles Wolff. *The Encyclopedia of Minor League Baseball.* Durham, NC: Baseball America, Inc., 1997.

Koppett, Leonard. *Koppett's Concise History of Major League Baseball.* Philadelphia: Temple University Press, 1998.

Kull, Andrew. *Baseball's Greatest Pitcher.* Farmington, NJ: American Heritage Press, 1985.

Levin, Leonard. *Days of Greatness: Providence Baseball 1875–1885.* Cooperstown, NY: Society of Baseball Research, 1984.

Lewine, Harris, and Daniel Okrent. *The Ultimate Baseball Book.* Boston: Houghton Mifflin Company, 1979.

*A Long Ago Book: Fun and Games of Long Ago.* Maynard, MA: Chandler Press, 1988.

MacFarlane, Paul. *Hall of Fame Fact Book.* St. Louis: Sporting News, 1983.

Madden, W.C. *The Women of the All-American Girls Professional Baseball League.* Jefferson, NC: McFarland and Company, Inc., 1997.

Matteson, Jeff F. *How To Bat.* New York: Spaulding's Athletic Library, American Publishing Company, 1905.

McKissack, Patricia C., and Frederick McKissack Jr. *Black Diamond: The Story*

# Bibliography

*of the Negro Baseball Leagues*. Scholastic Inc., n.d.

Mehrtens, Patricia Zifchock. *Images of America, Burrillville*. Dover, NH: Arcadia Publishing, 1996.

Mercurio, John A. *Record Profiles of Baseball Hall of Famers*. New York: Harper and Row Publishers, Inc., 1990.

Mullin, Willard. *World Series Encyclopedia, 1903–1960*. New York: Tomas Nelson and Sons, 1961.

Munro, Dr. Walter Lee. *The Old Back Campus at Brown*. Haley and Sykes Co., 1929.

Murphy, James M. *The Gabby Hartnett Story: From a Mill Town to Cooperstown*. Smithtown, NY: Exposition Press, 1983.

———. Unpublished Notes. Rhode Island Historical Files, P969q.

Nemec, David. *Great Baseball Feats, Facts and Firsts*. New York: Signet, 1989.

Nixon, Bill. *Warwick Neck*. Warwick Neck Improvement Association. 1991.

Okkonen, Marc. *The Federal League of 1914–1915: Baseball's Third Major League*. Pittsburgh, PA: Society of American Baseball Research, 1989.

Okrent, Daniel, and Harris Lewine. *The Ultimate Baseball Book*. Boston: Houghton Miflin Company, 1988.

O'Neal, Bill. The International League: *A Baseball History 1884–1991*. Austin, TX: Eakin Press, 1992.

Pietrusza, David, Matthew Silverman and Michael Gershman. *Baseball: The Biographical Encyclopedia*. New York: Total Sports Illustrated, 2000.

Solomon, Burt. *The Baseball Timeline*. New York: DK, 2001.

Soos, Troy. *Before the Curse: The Glory Days of New England Baseball, 1858–1918*. Hyannis, MA: Parnassus Imprints, 1997.

# Bibliography

*Spaulding's Official Baseball Guide*. New York: A.G. Spaulding and Bros., 1885.

*Spaulding's Official College Baseball Annual for 1914*. New York: Spaulding's Athletic Library, American Publishing Company, 1914.

Sullivan, Dean A. *Early Innings: A Documentary, History of Baseball, 1825–1908*. Bison Books, 1997.

Thorn, John. *The National Pastime*. New York: Bell Publishing Company, 1987.

Thorn, John, and Bob Carroll. *The Whole Earth Baseball Catalogue*. New York: Simon and Schuster, 1990.

Thorn, John, Pete Palmer, Michael Gershman, Matthew Silverman, Sean Lahman and Gref Spira. *Total Baseball V*. New York: Viking Press, 2001.

Tiemann, Robert L., and Mark Rucker. *Nineteenth Century Stars*. Manhattan, KS: Society of American Baseball Research, AG Press, 1989.

Turkin, Hy, and S.C. Thompson. *The Official Encyclopedia of Baseball*. 7th edition. New York: A.S. Barnes and Company, 1963.

Voigt, David Q. *American Baseball*. University of Oklahoma Press, 1966.

———. *Baseball: An Illustrated History*. University Park: Pennsylvania State University Press, 1987.

Weiner, Eric. *The Kids' Complete Baseball Catalogue*. Englewood Cliffs, NJ: Julian Messner, 1991.

Whitaker, Jim. *Coaching Youth Baseball*. Seekonk, MA: Copy Shop Etc., 1998.

*World Book Encyclopedia*. Chicago: Field Enterprises Educational Corporation, 1968.

Wray, J.F. *How To Play Third Base*. New York: Spaulding's Athletic Library, American Publishing Company, 1907.

Wright, Marshall D. *The International League 1884–1953*. Macfarland and Company, Inc., 1998.

# Bibliography

## Maps

*Atlas and Surveys of the State of Rhode Island and Providence Plantations.* Philadelphia: Everts and Richards, 1895.

*Atlas of the State of Rhode Island and Providence Plantations.* Philadelphia: D.G. Beers and Company, 1870.

*Plan of the Villages at Woonsocket Falls, RI.* 1838.

Sanborn-Perris Map Co. New York, 1880–1951.

*Street Atlas: Rhode Island.* Bridgewater, MA: Arrow Map, Inc., 1997.

## Newspapers, Periodicals and Journals

*Bristol Phoenix*

*Burrillville Gazette*, 1880–90.

*Cranston City News*, 1922.

*Cranston Herald*, 1941–46.

*Cranston Leader*, 1889.

*Cranston News*, 1922; 1924–26.

Murphy, James M. "Napoleon Lajoie, Modern Baseball's First Superstar." *National Pastime: A Review of Baseball History* (1988).

*Newport News*, 1897–1990.

*Olneyville Times*, 1887–88.

*Pascoag Herald*, 1892–96.

*Pawtucket Evening Times*, 1899–1949.

# BIBLIOGRAPHY

*Providence Evening Press*, 1872–77.

*Providence Journal*, 1860–1996.

*Sayles News*. Bound papers, Vol. 3, 12/1/1919–8/15/1921; Vol. 4, 9/1/1921–8/15/1922; Vol. 5, 9/1/1922–8/15/1923; Vol. 7, 9/1/1924–8/15/1925; Vol. 8, 9/1/1925–8/15/1926; Vol. 9, 9/1/1926–8/15/1917; Vol. 10, 9/1/1927–4/1/1928.

"Special Pictorial Issue: The Nineteenth Century." National Pastime: A Review of Baseball History.

Tiemann, Robert L., and Mark Rucker. "Nineteenth Century Stars." *National Pastime: A Review of Baseball History* (1989).

*Warren-Barrington Gazette*, 1909.

*Warwick Beacon*, 1996.

*Woonsocket (Evening) Call*, 1894–1999.

*Woonsocket Evening Reporter.*

## YEARBOOKS

*The Blue and White*. Providence, RI: Hope High School, 1906, 1908.

*Brun Mael*. Providence, RI: Pembroke College, 1933–36.

*The Caduceus*. Providence, RI: Classical High School, 1930.

*The Cranstonian*. Cranston, RI: Cranston High School, 1932.

*Expose*. Worcester, MA: Worcester Polytechnical Institute, 1892.

*Liber Bruensis*. Providence, RI: Brown University, 1872, 1874–1961.

*The Grist*. Kingston: Rhode Island State College, 1897–1961.

*RICOLED*. Providence: Rhode Island College of Education, 1937–39.

*The Tech Review*. Providence, RI: Technical High School, 1929–31.

# About the Author

Richard "Rick" Nyle Harris was born and raised in Iowa. He obtained a bachelor of fine arts degree in painting and drawing and later a master's in social work. He has been an adjunct professor at Rhode Island College School of Social Work since 1993. He is also an adjutant professor at Salve Regina University, where he teaches several courses, including two baseball courses looking at the sociological, historical and cultural impact of baseball in America. In addition to teaching part time, Rick works full time as the executive director of the National Association of Social Workers–Rhode Island Chapter.

Rick began his baseball research and writing career in 1992. He has presented at numerous baseball research conferences, provided countless public talks, written many articles and made several appearances on local television news shows. Most recently he appeared as the baseball historian in *You Must Be This Tall: The Story of Rocky Point*, a documentary film by David Bettencourt. Rick is a member of the American Society of Baseball Research (SABR) and the Rhode Island Historical Society.

Rick lives in Cranston, Rhode Island. He met his marriage partner Peg, a Rhode Island native, in 1974 and moved to Rhode Island that same year. Peg and Rick have two great children, Emily and Jacob, and one very old dog, Scruffy.

Visit us at
www.historypress.net